ART AND BEAUTY IN THE MIDDLE AGES

ART and BEAUTY
in the
MIDDLE AGES

UMBERTO ECO

Translated by Hugh Bredin

1986
Yale University Press
New Haven and London

Contents

Abbreviations

ET Edgar de Bruyne, *Études d'esthétique mediévale*, 3 vols. (Bruges, 1946).

LB Henri Pouillon, 'La Beauté, propriété transcendentale chez les scholastiques', *Archives d'histoire doctrinale et littéraire du moyen age*, XXI (1946), pp. 263–329.

PL J. P. Migne, *Patrologiae Cursus Completus. Series Latina* (Paris, 1844–90).

S.T. St. Thomas Aquinas, *Summa Theologiae*.

Translator's Note

In rendering Latin quotations into English I have used already published translations when these were available. For St. Thomas Aquinas's *Summa Theologiae* I depend upon the Blackfriars translation (60 vols., London and New York, 1964-76), and for his *Summa Contra Gentiles* upon *On the Truth of the Catholic Faith*, translated by Anton C. Pegis, James F. Anderson, Vernon J. Bourke, and Charles J. O'Neil (4 vols., New York, 1955-7). From time to time, however, I have replaced a published translation by my own.

My thanks are due to my wife Isabel, and to Sinead Smyth, who typed the manuscript.

H. B.

Preface

IN comparison with the eleven centuries covered by this overview of medieval aesthetics and with the five centuries that stand between the last authors I mention and my present readers, twenty-eight years are indeed a short lapse of time. However, I feel it is my duty to say that this book was written in 1958 and published in 1959, as 'Sviluppo dell'estetica medievale', a single chapter of a four volume handbook on the history of aesthetics, written by various authors (*Momenti e problemi di storia dell'estetica*, Milano, Marzorati, 1959, vol. 1: 'Dall'antichità classica al barocco', pp.115–230). This explains why I covered only the aesthetic theories of the philosophers writing in Latin (all the quotations were originally in Latin, since this handbook was conceived for an academic audience). It is true that I also refer to the secular culture whenever it is required to better understand the sense of a given philosophical statement, just as I frequently mention the patristic sources of the Schoolmen. But I do not deal expressly either with Augustine or with Dante for a very simple reason: in the first volume of that handbook Quintino Cataudella covered early Christian thought, Antonio Viscardi wrote on the literary theories of the Middle Ages and Giorgio Barberi Squarotti devoted a chapter to the theories of profane literature in the Italian fourteenth century (namely, Dante, Petrarch and Boccaccio). Thus, my contribution concerned the aesthetics of the Schoolmen, even though I paid due attention to their cultural environment.

My text was conceived for this handbook. I was not claiming to be original. My original contribution (if any) to the studies on medieval aesthetics was my book on the theory of beauty in Aquinas published in 1956 (*Il problema estetico in Tommaso d'Aquino*, 2nd revised

edition, Milano, Bompiani, 1970 – to be published in English by Harvard University Press). In 1958 it was unthinkable that a young scholar could provide new documents concerning such a large historical period, especially considering that in 1946 Edgar De Bruyne had published his seminal *Etudes d'esthétique médiévale*. What I tried to do was to provide a personal interpretation (and a very synthetic one) of a series of texts that in the previous decades had been discovered or rediscovered by other scholars. This made, and maybe still makes, my text readable to non-professional medievalists too, the more so because I tried to re-read the Schoolmen from the point of view of contemporary discussions on art and beauty. My standpoint was not a neo-Scholastic one, and I did not try to demonstrate that these old theories were still giving acceptable answers to our contemporary problems. However, I did try to show to what extent their problems and their answers could be understood by a contemporary reader, even when they appeared to be far removed from his/her concerns.

My text was written when I was 26 years old. When Yale University Press asked me to republish it I was rather reluctant. Then I decided to trust the publisher and the translator who said that some readers can still find my overview interesting. If I had to rewrite it today I would obviously take into account new bibliographical data. I would certainly revise the style. I thank Hugh Bredin for having made the English translation more palatable than the Italian original, but at that time I shared all the typical flaws of young (Italian) scholars and I believed that a tortured syntax was a respectable symptom of wisdom and maturity.

I would also add new reflections and perhaps deal with other minor authors. I would certainly rewrite the conclusion, taking into account other aspects of contemporary aesthetics (and semiotics) that can be compared with the Medieval thought. For instance, in the new conclusion of the second edition (1970) of my book on Aquinas, I draw a comparison between the Scholastic method and certain aspects of Structuralism. However, my basic opinions would not change and this is the only reason why I finally agreed to this belated edition. Maybe in this small book I tell my story with the clumsiness of a young scholar, but I tell a story in which I still believe.

For the curiosity of my readers, and in order to pay a nostalgic homage to my early years, I would like to remember the time when,

as soon as I had agreed to write this text, I had to spend eighteen months in the Italian Army. I am ever grateful to the lieutenant that gave me the daily opportunity to leave the barracks for the shelter of the comfortable library. Moreover, he provided me with a small office where I put all my books and files, as well as my typewriter (more efficient than those of the Esercito Italiano), and there I could work peacefully. I was a private and the lieutenant acted as my janitor, telling the intruders: 'don't disturb, professor at work.' I was so absorbed by medieval aesthetics that one day I lost my gun and I do not remember how and why I escaped the firing squad. But I was, as I still am, a bellicose pacifist.

Thus, it is arguable whether my book is more indebted to the Abbé Migne and Etienne Gilson or to Beetle Bailey, 'Tenent Fuzz, General Halftrack and Sergeant Snorkel. The Lord of Hosts bless them all.

Umberto Eco, 1986

Introduction

THIS short work attempts to investigate the historical development of certain aesthetic problems and aesthetic theories which engaged the energies of medieval Latin civilisation, in the period that stretched from the sixth to the fifteenth centuries.

The words 'medieval Latin' refer us in the first instance to Scholastic philosophy, along with the whole cultural context of that philosophy. But they refer us also to the culture of the common man, and my constant concern is to establish how the theories current at the time were related to its actual sensibility and its actual artistic products. My purpose in clarifying aesthetic theory is to discover how far it corresponded to, and how far it diverged from, the realities of the age – to discover what meaningful relations there were between medieval aesthetics and the other aspects of medieval culture and civilisation. I try to decide, in short, whether aesthetic theory provided effective answers to those questions which arose from the enjoyment, and the production, of whatever it was that beauty signified for medieval man; and whether, and how, theory was a stimulus and orientation for artistic experience and practice.

I hope that this way of putting it overcomes a common objection, namely, that the Middle Ages did not have an aesthetics, indulging itself instead with metaphysical concepts, concepts at once vague and arid, and further confused by their entanglement with fable and allegory.

Now clearly, if by aesthetics one meant a particular conception of art – for instance, Croce's theory that art is the lyrical intuition of feeling – then it would indeed be the case that medieval philosophy yielded no such 'aesthetics'. But this kind of reduction – a reduction of the

inquiry into art and the beautiful, which every epoch undertakes for itself, to the production of a particular aesthetics – is based upon a misunderstanding of method and an inexplicable warping of historical perspective.

Instead we must look for the ways in which a given epoch solved for itself aesthetic problems as they presented themselves at the time to the sensibilities and the culture of its people. Then our historical inquiries will be a contribution, not to whatever we conceive 'aesthetics' to be, but rather to the history of a specific civilisation, from the standpoint of its own sensibility and its own aesthetic consciousness. And if we set aside all ideological affinities with the theories examined, we may also discover which of them still possess some validity. In addition, we may be able to see more clearly which of our contemporary problems are rooted in medieval doctrines, doctrines too often dismissed as being far removed from our present interests.

The field of medieval aesthetics is a rich and rewarding one, and such monumental works as Edgar de Bruyne's *Études d'esthétique médiévale* have brought to light a great deal of material which had formerly gone unnoticed. In this work I shall examine some of the problems which engaged the medievals most intensely, and which seem to me the most worthy of attention. It seems preferable to discuss specific themes, rather than individual philosophers; for within each particular system references to aesthetic issues are often scattered and hard to synthesise, and ideas are often bandied back and forth among authors without, in many cases, undergoing any material change. Methodologically, medieval philosophy was deeply rooted in tradition. Innovation came without fanfare, even secretively, and developed by fits and starts until it was eventually absorbed within a free-and-easy syncretism. By looking at themes we can follow their evolution, tradition giving way to new and controversial ideas. We can trace how each problematic issue developed and matured, acquiring critical and scientific rigour on the way.

Medieval aesthetics began with a heritage received more or less uncritically from the Classical age – a heritage infused, all the same, by a spirit altogether new. Gradually there developed a metaphysics and epistemology of the beautiful, and eventually an idea of beauty as an organic value. This was the period of its greatest maturity. As we shall see, this conception subsequently declined. Traditional meta-

physical concepts began to crumble, and the concept of art and the poetic act became less and less systematic, a centre of disquiet. The Aristotelian tradition no longer provided adequate solutions. The foundations were laid for Mannerist doctrines of genius and imagination.

I. The Medieval Aesthetic Sensibility

1. MOST of the aesthetic issues that were discussed in the Middle Ages were inherited from Classical Antiquity. Christianity, however, conferred upon these issues a quite distinctive character. Some medieval ideas derived also from the Bible and from the Fathers; but again, these were absorbed into a new and systematic philosophical world. Medieval thinking on aesthetic matters was therefore original. But all the same, there is a sense in which its thinking might be said to involve no more than the manipulation of an inherited terminology, one sanctified by tradition and by a love of system but devoid of any real significance. It has been said that, where aesthetics and artistic production are concerned, the Classical world turned its gaze on nature but the Medievals turned their gaze on the Classical world; that medieval culture was based, not on a phenomenology of reality, but on a phenomenology of a cultural tradition.

This, however, is not an adequate picture of the medieval critical viewpoint. To be sure, the Medievals respected the concepts which they had inherited and which appeared to them a deposit of truth and wisdom. To be sure, they tended to look upon nature as a reflection of the transcendent world, even as a barrier in front of it. But along with this they possessed a sensibility capable of fresh and vivid responses to the natural world, including its aesthetic qualities.

Once we acknowledge this spontaneity in the face of both natural and artistic beauty – a response which was also elicited by doctrine and theory, but which expanded far beyond the intellectual and the bookish – we begin to see that beauty for the Medievals did not refer first to something abstract and conceptual. It referred also to everyday feelings, to lived experience.

The Medievals did in fact conceive of a beauty that was purely intelligible, the beauty of moral harmony and of metaphysical splendour. This is something which only the most profound and sympathetic understanding of their mentality and sensibility can restore to us nowadays.

When the Scholastics spoke about beauty they meant by this an attribute of God. The metaphysics of beauty (in Plotinus, for instance) and the theory of art were in no way related. 'Contemporary' man places an exaggerated value on art because he has lost the feeling for intelligible beauty which the neo-Platonists and the Medievals possessed. . . . Here we are dealing with a type of beauty of which Aesthetics knows nothing.[1]

Still, we do not have to limit ourselves to this type of beauty in medieval thought. In the first place, intelligible beauty was in medieval experience a moral and psychological *reality*; if it is not treated in this light we fail to do justice to their culture. Secondly, medieval discussions of non-sensible beauty gave rise to theories of sensible beauty as well. They established analogies and parallels between them or made deductions about one from premises supplied by the other. And finally, the realm of the aesthetic was much larger than it is nowadays, so that beauty in a purely metaphysical sense often stimulated an interest in the beauty of objects. In any case, alongside all the theories there existed also the everyday sensuous tastes of the ordinary man, of artists, and of lovers of art. There is overwhelming evidence of this love of the sensible world. In fact, the doctrinal systems were concerned to become its justification and guide, fearful lest such a love might lead to a neglect of the spiritual realm.[2]

The view that the Middle Ages were puritanical, in the sense of rejecting the sensuous world, ignores the documentation of the period and shows a basic misunderstanding of the medieval mentality.

[1] E. R. Curtius, *European Literature and the Latin Middle Ages*, translated by Willard R. Trask (London, 1953), p. 224, n. 20.

[2] Alcuin admitted that it was easier to love beautiful creatures, sweet scents, and lovely sounds (*species pulchras, dulces sapores, sonos suaves*) than to love God (C. Halm, *Rhetores Latini Minores* [Leipzig, 1863], p. 550). But he added that if we admire these things in their proper place – that is, using them as an aid to the greater love of God – then such admiration, *amor ornamenti*, is quite licit.

This mentality is well illustrated in the attitude which the mystics and ascetics adopted towards beauty. Ascetics, in all ages, are not unaware of the seductiveness of worldly pleasures; if anything, they feel it more keenly than most. The drama of the ascetic discipline lies precisely in a tension between the call of earthbound pleasure and a striving after the supernatural. But when the discipline proves victorious, and brings the peace which accompanies control of the senses, then it becomes possible to gaze serenely upon the things of this earth, and to see their value, something that the hectic struggle of asceticism had hitherto prevented. Medieval asceticism and mysticism provide us with many examples of these two psychological states, and also with some extremely interesting documentation concerning the aesthetic sensibility of the time.

2. In the twelfth century there was a noteworthy campaign, conducted by both the Cistercians and the Carthusians, against superfluous and overluxuriant art in church decoration. A Cistercian Statute denounced the misuse of silk, gold, silver, stained glass, sculpture, paintings, and carpets.[3] Similar denunciations were made by St. Bernard, Alexander Neckham, and Hugh of Fouilloi: these 'superfluities', as they put it, merely distracted the faithful from their prayers and devotions. But no one suggested that ornamentation was not beautiful or did not give pleasure. It was attacked just because of its powerful attraction, which was felt to be out of keeping with the sacred nature of its environment. Hugh of Fouilloi described it as a wondrous though perverse delight. The 'perversity' here is pregnant with moral and social implications, a constant concern of the ascetics; for them, the question was whether the churches should be decorated sumptuously if the children of God were living in poverty. On the other hand, to describe the pleasure as wondrous (*mira delectatio*) is to reveal an awareness of aesthetic quality.

In his *Apologia ad Guillelmum*, St. Bernard writes about what it is that monks renounce when they turn their backs upon the world. Here he reveals a similar viewpoint, though broadened to include worldly beauty of all kinds:

[3] *Consuetudines Carthusienses*, chap. 40 (PL, 153, col. 717).

We who have turned aside from society, relinquishing for Christ's sake all the precious and beautiful things in the world, its wondrous light and colour, its sweet sounds and odours, the pleasures of taste and touch, for us all bodily delights are nothing but dung . . . [4]

The passage is full of anger and invective. Yet it is clear that St. Bernard has a lively appreciation of the very things that he denounces. There is even a note of regret, all the more vigorous because of the energy of his asceticism.

Another passage in the same work gives even more explicit evidence of his aesthetic sensitivity. Bernard is criticising churches that are too big and cluttered up with sculpture, and in so doing he gives an account of the Cluny style of Romanesque which is a model of critical description. He is contemptuous, yet paradoxically so, for his analysis of what he rejects is extraordinarily fine. The passage begins with a polemic against the immoderate size of churches: 'Not to speak of their enormous height, their immoderate length, their vacant immensity, their sumptuous finish, the astonishing paintings that confuse the eye during prayer and are an obstacle to devotion – to me they call to mind some ancient Jewish ritual.' Can it be, he goes on to ask, that these riches are meant to draw riches after them, to stimulate financial donations to the Church? 'Everything else is covered with gold, gorging the eyes and opening the purse-strings. Some saint or other is depicted as a figure of beauty, as if in the belief that the more highly coloured something is, the holier it is . . . ' It is clear enough what he is denouncing here, and on the whole one is disposed to agree with him. It is not aesthetic qualities that are under question, but the use of the aesthetic for a purpose foreign to the nature of religion, for monetary profit. 'People run to kiss them, and are invited to give donations; it amounts to a greater admiration for beauty than veneration for what is sacred.' This is his point: ornament distracts from prayer. And if it does this, what use are the sculptures, the decorated capitals?

In the cloisters meanwhile, why do the studious monks have to face such ridiculous monstrosities? What is the point of this deformed

[4] This, and the quotations from St. Bernard immediately following, are in his *Apologia ad Guillelmum*, chap. 12 (PL, 182, cols. 914–16).

beauty, this elegant deformity? Those loutish apes? The savage lions? The monstrous centaurs? The half-men? The spotted tigers? The soldiers fighting? The hunters sounding their horns? You can see a head with many bodies, or a body with many heads. Here we espy an animal with a serpent's tail, there a fish with an animal's head. There we have a beast which is a horse in front and a she-goat behind; and here a horned animal follows with hind-quarters like a horse. In short there is such a wondrous diversity of figures, such ubiquitous variety, that there is more reading matter available in marble than in books, and one could spend the whole day marvelling at one such representation rather than in meditating on the law of God. In the name of God! If we are not ashamed at its foolishness, why at least are we not angry at the expense?

A noteworthy feature of these passages is their style, which is exceptionally well-wrought by the standards of the time. In fact this is typical of the mystics (St. Peter Damien is another who comes to mind): their denunciations of poetry and the plastic arts are models of style. This need not be particularly surprising, for nearly all of the medieval thinkers, whether mystics or not, went through a poetic stage in their youth. Abelard did, and so did St. Bernard, the Victorines, St. Thomas Aquinas, St. Bonaventure. In some cases they produced mere stylistic exercises, but in others they wrote some of the most exalted poetry in medieval Latin. We need only mention Aquinas's Office of the Blessed Sacrament.

The ascetics, however, had views whose extremity makes them all the more suitable for the present argument. For they campaigned against something whose fascination they were well able to understand, and felt to be dangerous as well as praiseworthy. In feeling this they had a precedent in the passionate sincerity of St. Augustine, writing in his *Confessions* about the man of faith, perturbed by the fear that he may be seduced from his prayers by the beauty of the sacred music.[5]

St. Thomas Aquinas, in similar though more amiable tones, advised against the use of instrumental music in the Liturgy. It should be avoided, he said, precisely because it stimulates a pleasure so acute that it diverts the faithful from the path appropriate to

[5] St. Augustine, *Confessions*, X, 33.

sacred music. The end of religious music is best achieved by song. Song provokes the soul to greater devotion, but instrumental music, he wrote, 'moves the soul rather to delight than to a good interior disposition'.[6] This clearly involves recognition of an aesthetic reality, valid in itself but dangerous in the wrong place.

When the medieval mystic turned away from earthly beauty he took refuge in the Scriptures and in the contemplative enjoyment of the inner rhythms of a soul in the state of grace. Some authorities speak of a 'Socratic' aesthetics of the Cistercians, one founded upon the contemplation of the beauty of the soul. 'Interior beauty', wrote St. Bernard, 'is more comely than external ornament, more even than the pomp of kings'.[7] The bodies of martyrs were repulsive to look upon after their tortures, yet they shone with a brilliant interior beauty.

The contrast between external and internal beauty was a recurrent theme in medieval thought. There was also a sense of melancholy, because of the transience of earthly beauty. Boethius is a moving example, lamenting on the very threshold of death, 'The beauty of things is fleet and swift, more fugitive than the passing of flowers in Spring . . . '[8] This is an aesthetic variation on the moralistic theme of *ubi sunt*, a constant theme in medieval culture: where are the great of yesteryear, where are the magnificent cities, the riches of the proud, the works of the mighty? In the background of the *danse macabre*, the triumph of death, we find in various forms a melancholy sense of the beauty that passes. The man of steadfast faith may look on at the dance of death with serenity and hope, but suffer a pang of sorrow none the less. We think of Villon's most poignant refrain: *mais ou sont les neiges d'antan*?

Confronted with the beauty that perishes, security could be found in that interior beauty which does not perish. The Medievals, in fleeing to this kind of beauty, restored the aesthetic in the face of death. If men possessed the eyes of Lynceus, Boethius wrote, they would see how vile was the soul of Alcibiades the fair, he whose beauty seemed so worthy of love.[9] But this was a somewhat cantankerous kind of

[6] S.T., II–II, 91, 2.
[7] St. Bernard, *Sermones in Cantica*, XXV, 6 (PL, 183, col. 901).
[8] Boethius, *The Consolation of Philosophy*, III, 8.
[9] Boethius, *The Consolation of Philosophy*, III, 8.

sentiment, and Boethius's study of the mathematics of music was quite different in spirit. So too were a number of texts that dealt with the beauty of an upright soul in an upright body, a Christian ideal of the soul externally revealed. Gilbert of Hoyt writes: 'And have regard also for the bodily countenance whose grace can be seen in its abundant beauty; for the exterior face can refresh the spirit of those who look upon it, and nourish us with the grace of the interior to which it witnesses.'[10] And here is St. Bernard:

> When the brightness of beauty has replenished to overflowing the recesses of the heart, it is necessary that it should emerge into the open, just like the light hidden under a bushel: a light shining in the dark is not trying to conceal itself. The body is an image of the mind, which, like an effulgent light scattering forth its rays, is diffused through its members and senses, shining through in action, discourse, appearance, movement – even in laughter, if it is completely sincere and tinged with gravity.[11]

Thus, at the very heart of ascetical polemics we discover a sense of human and natural beauty. And in Victorine mysticism, where discipline and rigour became subsumed in the serenity of knowledge and love, natural beauty was finally recovered in all its positive value. For Hugh of St. Victor, contemplation requires the use of intelligence; and it is not confined to specifically mystical experience but can arise also when attending to the sensible world. Contemplation, he writes, is 'an easy and clearsighted penetration of the soul into that which is seen';[12] and this then merges into a delighted attachment to the objects of love. An aesthetic pleasure arises when the soul finds its own inner harmony duplicated in its object. But there is also an aesthetic element when the intellect freely contemplates the wonder and beauty of earthbound form. 'Look upon the world and all that is in it: you will find much that is beautiful and desirable . . . Gold . . . has its brilliance, the flesh its comeliness, clothes and ornaments their colour . . . '[13]

We see, therefore, that the aesthetic writings of the period do not

[10] Gilbert of Hoyt, *Sermones in Canticum Salomonis*, XXV, 1 (PL, 184, col. 129).

[11] *Sermones in Cantica*, LXXV, 11 (PL, 183, col. 1193).

[12] Hugh of St. Victor (Hugh of Paris), *De Modo Dicendi et Meditandi*, 8 (PL, 176, col. 879).

[13] Hugh of St. Victor, *Soliloquium de Arrha Animae* (PL, 176, col. 951).

consist merely of theoretical discussions of the beautiful, but are full of expressions of spontaneous critical pleasure. It is these which demonstrate how closely the sensibility of the time was interwoven with its theoretical discourses. The fact that they are found in the writings of the mystics gives them, if anything, an added demonstrative value.

One last example involves a subject very common in medieval times: female beauty. It is not perhaps too surprising that Matthew of Vendôme should formulate rules for describing beautiful women in his *Ars Versificatoria*;[14] in fact he was only half serious, indulging in a kind of erudite joke in imitation of the ancients. Also, it seems reasonable that laymen should possess greater sensitivity to the natural world. But we also find Ecclesiastics, writing on the *Canticle of Canticles*, discoursing on the beauty of the Spouse. Even though their aim was to discover allegorical meanings in the text, supernatural analogues of the physical attributes of the dark but shapely maid – still, every so often we find them pontificating on the proper ideal of female beauty, and revealing in the process a quite spontaneous appreciation of women which is earthy enough for all its chastity. Baldwin of Canterbury bestowed his praises upon plaits. He was allegorising, but this fails to conceal his sensitive taste in matters of fashion, for he described the beauty of plaits persuasively and with exactitude, and referred explicitly to their wholly aesthetic appeal.[15] Or there is the singular passage in Gilbert of Hoyt where he defines the correct dimensions of the female breasts, if they are to be truly pleasing. Only nowadays, perhaps, can we see that his gravity is suffused with a certain malice. His ideal reminds us of the ladies of medieval miniaturists, their tight corsets binding and raising the bosom. 'The breasts are most pleasing when they are of moderate size and eminence. . . . They should be bound but not flattened, restrained with gentleness but not given too much licence'.[16]

3. If we turn from the mystics to other spheres of medieval culture,

[14] Matthew of Vendôme, *The Art of Versification*, translated by Aubrey E. Galyon (Ames, Iowa, 1968).

[15] Baldwin of Canterbury, *Tractatus de Vulnere Charitatis* (PL, 204, col. 481).

[16] *Sermones in Canticum Salomonis*, XXXI, 4 (PL, 184, col. 163).

lay or ecclesiastical, we can no longer question the existence of sensitive responses to natural and artistic beauty.

Some authorities claim that the Medievals never discovered how to connect their metaphysical concepts of beauty with their knowledge of artistic techniques, that these were two distinct and unrelated worlds. I hope to cast doubt on this view. To begin with, there was at least one area of language and sensibility where art and beauty were connected, with no apparent difficulty. It is an area well documented in Victor Mortet's *Recueil de textes relatifs à l'histoire de l'architecture*.[17] In these records of cathedral construction, correspondence on questions of art, and commissions to artists, metaphysical aesthetic concepts mingle constantly with artistic judgments. It is quite clear that this intermingling was an everyday affair. Whether it was recognised also on the philosophical level I shall discuss below.

Another question is this. The Medievals habitually employed their art for didactic purposes. Did they, then, ever advert to the possibility of a disinterested aesthetic experience? The issue here, about the autonomy of beauty in art, is ultimately about the nature and the limits of medieval critical taste. There are many texts which could be used to answer these questions, but a few that are especially representative and significant ought to suffice.

J. Huizinga, in *The Waning of the Middle Ages*, observes that 'the consciousness of aesthetic pleasure and its expression are of tardy growth. A fifteenth-century scholar like Fazio, trying to vent his artistic admiration does not get beyond the language of commonplace wonder.'[18] Now this observation is in part correct. But none the less, one must be careful not to equate an imprecision of language with the absence of a state of aesthetic contemplation. What must be noted is how feelings of artistic beauty were converted at the moment of their occurrence into a sense of communion with God and a kind of *joie de vivre*. In fact Huizinga himself takes note of this.[19] Was not this manner of apprehending beauty appropriate to an age marked by an extraordinary integration of values?

The twelfth century provides a prototype of the medieval man of

[17] Victor Mortet, *Recueil de textes relatifs à l'histoire de l'architecture*, 2 vols. (Paris, 1911, 1929).
[18] J. Huizinga, *The Waning of the Middle Ages*, translated by F. Hopman (Harmondsworth, 1965), pp. 254–5.
[19] J. Huizinga, p. 256.

taste and the art lover, in the person of Suger, Abbot of St. Denis. A statesman and a humanist, Suger was responsible for the principal artistic and architectural enterprises on the Île de France.[20] He was a complete contrast, both psychologically and morally, to an ascetic like St. Bernard. For the Abbot of St. Denis, the House of God should be a repository of everything beautiful. King Solomon was his model, and his guiding rule *dilectio decoris domus Dei*. The Treasury at St. Denis was crammed with jewellery and *objets d'art* which Suger described with loving exactitude. Thus, he writes of

> a big golden chalice of 140 ounces of gold adorned with precious gems, viz., hyacinths and topazes, as a substitute for another one which had been lost as a pawn in the time of our predecessor . . . [and] . . . a porphyry vase, made admirable by the hand of the sculptor and polisher, after it had lain idly in a chest for many years, converting it from a flagon into the shape of an eagle.[21]

And in the course of enumerating these riches he expresses his pleasure and enthusiasm at ornamenting the church in such a wondrous manner.

> Often we contemplate, out of sheer affection for the church our mother, these different ornaments both old and new; and when we behold how that wonderful cross of St. Eloy – together with the smaller ones – and that incomparable ornament commonly called 'the Crest' are placed upon the golden altar, then I say, sighing deeply in my heart: 'Every precious stone was thy covering, the sardius, the topaz, and the jasper, the chrysolite, and the onyx, and the beryl, the sapphire, and the carbuncle, and the emerald.'[22]

One is inclined to agree with Huizinga's evaluation of passages like these – that Suger is impressed chiefly by the precious metals, the gems and the gold. The predominant sentiment is one of amazement, a sense of the *kolossal*, rather than of beauty. Suger is thus like the

[20] See Erwin Panofsky, *Abbot Suger on the Abbey Church of St.-Denis and its Art Treasures* (Princeton, 1946). Also Elizabeth G. Holt, *A Documentary History of Art*, 2 vols. (New York, 1957), I, pp. 22–48. Suger's *De Rebus Administratione sua Gestis* is in PL, 186, cols. 1211–39.

[21] Erwin Panofsky (1946), pp. 77, 79.

[22] Erwin Panofsky (1946), p. 63.

other collectors of the Middle Ages, who filled their storehouses not just with artworks, but also with absurd oddities. The duc de Berry's collection included the horn of a unicorn, St. Joseph's engagement ring, coconuts, whales' teeth, and shells from the Seven Seas.[23] It comprised around three thousand items. Seven hundred were paintings, but it also contained an embalmed elephant, a hydra, a basilisk, an egg which an Abbot had found inside another egg, and manna which had fallen during a famine. So we are justified in doubting the purity of medieval taste, their ability to distinguish between art and teratology, the beautiful and the curious.

None the less Suger's somewhat naive inventories, in which he uses almost exclusively a terminology descriptive of precious materials, display a noteworthy union of two elements. There is an ingenuous liking for anything giving an immediate pleasure – and this is an elementary form of aesthetic response; and there is also an uncritical awareness of the materials used in works of art – an awareness that the choice of material is itself a primary and fundamental creative act. This pleasure in the material, rather than in the shaping process, suggests a kind of commonsense stability in the medieval aesthetic response.

Huizinga frequently observes that the Medievals allowed the imagination free rein instead of fastening it to the unique art object before them. This is true, and I shall return to this point. But here we should note that Suger, yet again, has documented for us the medieval transformation of aesthetic pleasure into a mystical *joie de vivre*. There is an ecstatic quality in his experiences of beauty in the church.

> Thus, when – out of my delight in the beauty of the house of God – the loveliness of the many-coloured gems has called me away from external cares, and worthy meditation has induced me to reflect, transferring that which is material to that which is immaterial, on the diversity of the sacred virtues: then it seems to me that I see myself dwelling, as it were, in some strange region of the universe which neither exists entirely in the slime of the earth nor entirely in the purity of Heaven; and that, by the grace of God, I can be transported from this inferior to that higher world in an anagogical manner.[24]

[23] See J. Guiffrey, *Inventaire de Jean, duc de Berry* (Paris, 1894–6).
[24] Erwin Panofsky (1946), pp. 63, 65.

We should note a number of features of this passage. The sensuous presence of the artistic materials clearly provokes a genuinely aesthetic experience. And the experience is neither a simple pleasure in the sensuous, nor an intellectual contemplation of the supernatural. The passage from aesthetic pleasure to mystical joy is virtually instantaneous, more so than the term 'anagogical' suggests. Medieval taste, we may conclude, was concerned neither with the autonomy of art nor the autonomy of nature. It involved rather an apprehension of all of the relations, imaginative and supernatural, subsisting between the contemplated object and a cosmos which opened on to the transcendent. It meant discerning in the concrete object an ontological reflection of, and participation in, the being and the power of God.

4. All of these texts have the effect, not of denying to the Medievals an aesthetic sensibility, but of defining the peculiarities of the aesthetic sensibility which they actually possessed. The concept of integration comes to suggest itself in a central explanatory role, where an integrated culture is taken to mean a culture whose value systems are related to one another, within the culture's necessary limitations, by mutual implication.

This integration of values makes it difficult for us to understand nowadays the absence in medieval times of a distinction between beauty (*pulchrum*, *decorum*) and utility or goodness (*aptum*, *honestum*). These terms are sprinkled throughout Scholastic literature and medieval treatises on poetic technique. Often enough the two categories were distinguished on the theoretical level. Isidore of Seville, for instance, said that *pulchrum* refers to what is beautiful in itself, and *aptum* to what is beautiful relative to something else[25] – a formulation inherited from Classical Antiquity, passing from Cicero through St. Augustine to Scholasticism in general. But the medieval view of art in practice, as opposed to theory, tended to mingle rather than to distinguish the two values. The very author who celebrated the beauty of art insisted also upon its didactic function. Suger himself adopted the positions sanctioned at the Synod of Arras in 1025, that whatever the common people could not grasp from the Scriptures

[25] St. Isidore of Seville, *Sententiarum Libri*, I, 8, 18 (PL, 83, cols. 551–2).

should be taught to them through the medium of pictures. Honorius of Autun wrote that the end of painting was threefold: one was 'that the House of God should be thus beautified'; a second was that it should recall to mind the lives of the Saints; and finally, 'Painting . . . is the literature of the laity'.[26] The accepted opinion as far as literature was concerned was that it should 'instruct and delight', that it should exhibit both the nobility of intellect and the beauty of eloquence. This was a basic principle in the aesthetics of the Carolingian *literati*.

These views were often abused by being too strenuously pressed. But we should note that they do not represent a myopic and primitive didacticism. The fact was, that the Medievals found it extremely difficult to separate the two realms of value, not because of some defect in their critical sense, but because of the unity of their moral and aesthetic responses to things. Life appeared to them as something wholly integrated. Nowadays, perhaps, it may even be possible to recover the positive aspects of their vision, especially as the need for integration in human life is a central preoccupation in contemporary philosophy. The way of the Medievals is no longer open to us, but at least the paradigm they offer us can be a source of valuable insights, and their aesthetic doctrines are here of great importance.

It was not by chance that one of the main problems of Scholastic aesthetics was the problem of integrating, on the metaphysical level, beauty with other forms of value. Their discussions of the transcendental character of beauty constituted one of the main attempts to establish a ground for their integrated sensibility. They tried to allow both for the autonomy of aesthetic value and for its place within a unitary scheme of values – or, to put it in medieval terms, within a unitary vision of the transcendental aspects of being.

[26] Honorius of Autun, *Gemma Animae*, chap. 132 (PL, 172, col. 586).

II. Transcendental Beauty

A constantly recurring theme in medieval times was the beauty of being in general. It was a period in whose history darkness and contradiction may be found, but its philosophers and theologians had an image of the universe that was filled with light and optimism. As Genesis taught, 'God saw all that he had made, and found it very good. . . . Thus heaven and earth and all the furniture of them were completed.'[1] And the Book of Wisdom taught also that God created the world according to number, weight, and measure.[2] As we shall see, these concepts were taken to be aesthetic as well as cosmological, and also as expressions of the Good, the metaphysical *Bonum*.

It was the Scriptures, then, extended and amplified by the Fathers, which produced this pancalistic vision of the cosmos. But it was confirmed also by the Classical heritage. The theory that the beauty of the world is an image and reflection of Ideal Beauty is Platonic in origin. When Chalcidius, in his Commentary on the *Timaeus*, wrote of the world's incomparable beauty, he was echoing the conclusion of a work fundamental in the formation of medieval thought.

> For with this our world has received its full complement of living creatures, mortal and immortal, and come to be in all its grandeur, goodness, beauty and perfection – this visible living creature made in the likeness of the intelligible and embracing all the visible, this god displayed to sense, this our heaven, one and only-begotten.[3]

[1] *Genesis*, I, 31 and II, 1.
[2] *Wisdom*, XI, 21.
[3] Plato, *Timaeus*, translated by A. E. Taylor (London, 1929), p. 100.

And Cicero adds his voice in his *De Natura Deorum*: 'Nothing is better than this earth, nor more excellent and beautiful'.[4]

These confident statements of Classical pancalism were translated in medieval times into even more emphatic terms – a consequence in part of the Christian sentiment of love for God's handiwork, and in part also of neo-Platonism. These two influences came together most fruitfully in the *De Divinis Nominibus* of Dionysius the Areopagite. It is a work which describes the universe as an inexhaustible irradiation of beauty, a grandiose expression of the ubiquity of the First Beauty, a dazzling cascade of splendours.

> But the Superessential Beautiful is called 'Beauty' because of that quality which It imparts to all things severally according to their nature, and because It is the Cause of the harmony and splendour in all things, flashing forth upon them all, like light, the beautifying communications of Its originating ray; and because It summons all things to fare unto Itself (from whence It hath the name of 'Fairness')*, and because It draws all things together in a state of mutual interpenetration.[5]

None of the commentators on Dionysius could resist this fascinating vision, which already conferred some kind of philosophical status, however limited and vague, upon a natural and spontaneous sentiment of the medieval soul. John Scotus Eriugena conceived of the universe as a revelation of God in His ineffable beauty, God reflected both in material and in ideal beauty, and diffused in the loveliness of all creation. All things, like and unlike, forms and genera, the different orders of substantial and accidental causes, combined together in a marvellous unity.[6] There was not a single medieval writer who did not turn to this theme of the polyphony of the universe; and we find often enough that along with the calm and control of philosophical language there sounded a cry of ecstatic joy: 'When you consider the order and magnificence of the universe

* ὡς πάντα πρὸς ἑαυτὸ καλοῦν (ὅθεν καὶ κάλλος λέγεται).

[4] Cicero, *De Natura Deorum*, II, 7.

[5] Dionysius the Areopagite, *The Divine Names*, translated by C. E. Holt (London 1920), pp. 95–6.

[6] See John Scotus Eriugena, *On the Division of Nature*, translated by Myra L. Uhlfelder (Indianapolis, 1976), III, 6.

. . . you will find it to be like a most beautiful canticle . . . and the wondrous variety of its creatures to be a symphony of joy and harmony to very excess.'[7]

Quite a number of concepts were constructed in order to give philosophical expression to this aesthetic vision of the universe. But they all derived ultimately from the triad of terms given in the Book of Wisdom: number (*numerus*), weight (*pondus*), and measure (*mensura*). Thus we find triads such as dimension, form, and order (*modus, forma, ordo*); substance, nature, and power (*substantia, species, virtus*); that which determines, that which proportions, and that which distinguishes (*quod constat, quod congruit, quod discernit*); and so on and so forth. However, terms such as these were not always co-ordinated systematically. Also, they had to serve another purpose – to define the good as well as the beautiful. Here for instance is William of Auxerre: 'The goodness of a substance, and its beauty, are the same thing. . . . The beauty of a thing consists in these three attributes (species, number and order) – the very same in which Augustine says its goodness consists.'[8]

But at a certain point in its development, Scholasticism felt the need to systematise these triads of terms – to define once and for all, and with philosophical rigour, this pancalistic sensibility which was so widespread yet so vague and lyrical, lending itself to metaphorical rather than to scientific language.

Thus in the thirteenth century a considerable critical effort was devoted to finding a rigorous solution to this problem. It was an effort provoked in part by the revival of Manichaeism expressed in the heresies of the Cathari and the Albigensians. Scholastics were confronted with the view that the world manifests essentially a struggle of uncertain outcome between good and evil, and they sought in reply to demonstrate the positive character of creation, even where it seemed at its darkest.

The strategy which they developed for this purpose involved the theory that transcendental properties were 'concomitant conditions' of being. If it were established that the values of unity, truth, and

[7] William of Auvergne, *De Anima*, V, 18, quoted in LB.
[8] William of Auxerre, *Summa Aurea*, quoted in LB.

goodness are not actualised sporadically and accidentally, but adhere rather to being as co-extensive metaphysical properties, then it would follow that all existence is one, true, and good.

This was the intellectual climate of Philip the Chancellor's _Summa de Bono_. Written at the very beginning of the thirteenth century, it was the first attempt to establish a precise meaning for the concept of the transcendental. It sketched out a system based upon Aristotle's discussions of the one and the true in his _Metaphysics_,[9] though it was influenced also by Arabic Aristotelians. Mindful of the struggle against Manichaeism, Philip gave special emphasis to the concept of goodness; and, inspired by the Arabs, he developed a theory of identity and convertibility of the transcendentals. Transcendentals differed only _secundum rationem_ – that is, according to the way in which we conceive of things. 'Good is convertible with being . . . for goodness abounds in being in accord with reason.'[10] The Good is being seen in its perfection, in its correspondence with the end to which it tends. Oneness is being seen under the aspect of its indivisibility.

Philip himself made no reference to beauty. But many of his contemporaries did, especially in commentaries on the Pseudo-Dionysius. This author's constant references to beauty forced them to enquire whether beauty was not also a transcendental. His commentators sought to do three things. First, they wanted to formulate a rigorous definition of beauty which would reflect their pancalistic sensibility. Secondly, they wanted to explain the various triads which I have mentioned above (number, weight, measure, and so on) by combining them together into the language of transcendentals. Thirdly, they wanted to clarify the relations between the good and the beautiful, and to do so at a deep metaphysical level, consonant with the requirements of the Scholastic methodology. The climate of the time was one of integrated values. Its sensibility breathed the spirit of the Greek _kalokagathìa_, the good and the beautiful combined, albeit a spirit modified by Christianity. So Scholastic philosophy aspired to establish the ground of this identity of values, and also the respects in which values were autonomous. If it could be shown that beauty

[9] Aristotle, _Metaphysics_, III, 3; IV, 2; X, 2.
[10] Philip the Chancellor, _Summa de Bono_. Quoted in Henri Pouillon, 'Le Premier Traité des propriétés transcendentales', _Revue néoscholastique de philosophie_, XLII (1939), pp. 40–77.

was a constant property of being a whole, then the beauty of the universe would be founded on a metaphysical certainty, and not on mere poetic sentiment. The need for a distinction among the transcendentals *secundum rationem* led to a definition of the specific conditions under which something was seen to be beautiful – that is, the conditions of beauty's autonomy within an ultimate unity of values.

All of this serves to show that at a certain point philosophy felt the need to undertake an analysis of aesthetic problems. In the early Middle Ages there were many references to beauty, but also a marked reluctance to develop any specific concepts connected with it. There is an interesting illustration of this in the way that different translators dealt with the words *kalòn* and *kàllos* in the Pseudo-Dionysius. In 827 the first translator, Hilduin, translated a sentence in *De Divinis Nominibus* as follows: 'Goodness and that which is good are not separately referable to a single all-encompassing cause. . . . for a thing is called good because it participates in goodness . . . ' *Kalòn* was taken to signify an ontological sense of 'good'. But three centuries later Johannes Saracenus translated the same lines thus: 'Beauty and that which is beautiful are not separately referable to a single all-encompassing cause . . . for a thing is called beautiful because it participates in beauty . . . '[11] This translator, in a letter to John of Salisbury, recalls that he had translated Dionysius according to the sense rather than the letter.[12] What is involved here is not just a greater philological accuracy, but a difference in content; for to translate according to sense is to subject the words to interpretation. As de Bruyne puts it, Johannes Saracenus was a whole world away from Hilduin.[13] That is, there was more than just a doctrinal difference between them, more than just an increase in understanding of the text. Much had happened in the centuries between Hilduin and Saracenus: the end of the Dark Ages, the Carolingian Renaissance, the humanism of Alcuin and Rhabanus Maurus, the passing of the terrors of the year 1000, a new sense of the positive aspects of life, an evolution from feudalism to guilds, the early Crusades, the opening of trade routes, the Romanesque period with its great pilgrimages to

[11] These two translations are given side by side in ET, I, p. 359.
[12] PL, 199, col. 259.
[13] ET, loc. cit.

Santiago de Compostella, the first flowering of Gothic. Man's sensitivity to the aesthetic had been enriched by a renewed interest in physical appearances, and there was an attempt to enfold the new vision of the world within the canons of theology. In these centuries we find that beauty begins to acquire the status of a transcendental, semi-consciously at first. At the beginning of the eleventh century, for instance, Otloh of St. Emmeran attributed a fundamental feature of beauty, consonance (*consonantia*), to every creature.[14] And there gradually came into being various theories of the cosmic order and musical structure of the universe, theories which I shall look at later. Finally, equipped with the terminological weapons furnished by enquiries such as that of Philip the Chancellor, the thirteenth century began diligent and precise investigation of the concepts in question and their interrelations.

William of Auvergne's *Tractatus de Bono et de Malo* appeared in 1228.[15] In it he discussed the beauty of upright behaviour. He argued that, since sensuous beauty is that which pleases him who sees it (I shall return to this interesting formula), interior beauty is that which gives pleasure to the soul which grasps it 'and entices the soul to love it'. And the goodness found in the human soul 'is called *pulchritudo* or *decor* because of the comparison with external and visible beauty'. This equivalence of moral beauty and the good was a conception inherited from the Stoics, from Cicero and from Augustine, very likely from Aristotle's *Rhetoric* as well.[16]. But William was content to leave it at that, and did not develop the theory further.

The relation of beauty and the good was often discussed in commentaries upon the works of Dionysius – that of Thomas Gallus Vercellensis, for instance, which can be dated to 1242. Robert Grosseteste's commentary comes from about the same time (prior to 1243). Grosseteste attributed the name of Beauty (*Pulchritudo*) to God, and wrote, 'If everything desires the good and the beautiful together, the good and the beautiful are the same'.[17] But he added that the two attributes, though united in the objects which possessed

[14] Otloh of St. Emmeran, *Dialogus de Tribus Quaestionibus*, chap. 43 (PL, 146, col. 120).

[15] The passages quoted from this are given in LB.

[16] 'The beautiful is that which is desirable for its own sake, and pleasant, or that which, being good, is pleasureable because it is good', Aristotle, *Rhetoric*, 1366a 33.

[17] This and the following quotation are given in LB.

them, united also in God, whose names manifest the beneficent creative processes which proceed from Him to His creatures, are at the same time logically or conceptually different (*diversa sunt ratione*):

> God is called good because He confers being on everything, and being is good, and He increases and perfects and preserves. But He is called beautiful in that all things, both in themselves and together, produce a concordance in their identity with Him.

Goodness is ascribed to God in so far as He is the source of existence and maintains things in being; beauty is ascribed to Him in so far as He is the 'organising Cause' of creation. This way of talking about God was of enormous importance in aesthetics as well. And it is worth noting that Philip the Chancellor's distinction of the one and the true was adapted by Grosseteste in order to distinguish goodness and beauty.

A work of fundamental importance appeared in 1245, although Grosseteste seems to have read it prior to this. Known as the *Summa* of Alexander of Hales, it had in fact three authors: John of la Rochelle, Alexander himself, and a third tentatively identified as 'Brother Considerans'.[18] It decisively solved the problem of the transcendental character of beauty, and its distinction from other values. John of la Rochelle asked this question: are the good and the beautiful the same with respect to the intentionality (*intentio*) of the percipient? The very question was a novel one. He simply took it for granted that the good and the beautiful were identical in objects themselves, and subscribed to the Augustinian view that honour or nobility (*honestum*) belonged in the realm of intelligible beauty. None the less, the good and the beautiful were different, 'For beauty is a disposition of the good in so far as it pleases the apprehension, whereas the good strictly speaking has to do with the disposition in which it pleases our affections.'[19] He goes on to add that good is related to final causes, beauty to formal causes. The word 'form' (*forma*) in the *Summa* of Alexander was used in the Aristotelian sense; it referred to the substantial principle of life. Truth and beauty were then both defined in terms of form: truth was the disposition of form in relation to the internal

[18] Alexander of Hales, *Summa Theologica* (Florence, 1924, 1928, 1930, 1948).
[19] Alexander of Hales, I, n. 103.

character of a thing; beauty was the disposition of form in relation to its external character. In this way, beauty was given a new foundation, for the true, the good, and the beautiful were convertible. They differed only *ratione* – conceptually, logically.

There are important differences here from the apparently similar views of Grosseteste. Grosseteste also said that the good and the beautiful differed *ratione* – but in his case it was a difference in the mind of the Creator, and in the process of creation. In the *Summa* of Alexander, the difference *ratione* is a difference *intentione* – that is, in intentionality. Beauty is thus defined in relation to the knowing subject. Again, Grosseteste regarded Good and Beauty as names for God, and so as identical within the divinely diffused unity of life. Whereas in the *Summa* the two values were grounded primarily in the concrete form of things.

All the same, it was not found necessary to add beauty to the list of transcendentals. The authors of the *Summa* refrained from doing so, no doubt because of the usual prudent reluctance of the Scholastics to give an open and unambiguous welcome to philosophical innovations. All the succeeding philosophers were more or less equally cautious. For this reason, St. Bonaventure seems all the more daring in his almost unnoticed opusculum of 1250.[20] Here, he speaks explicitly of 'four conditions of a being, namely that it be one, true, good, and beautiful'. He explains the identity and difference of the four conditions as follows: *unum* has to do with the efficient cause, *verum* with the formal cause, and *bonum* with the final cause; but *pulchrum* 'encompasses every cause and is common to each ... It has to do equally with every cause'. In short, Bonaventure defines beauty as 'the splendour of all the transcendentals together', to use an expression of Maritain's (though Maritain does not seem to have known this particular passage).[21]

But the *Summa* of Alexander contained the seeds of even more radical, if less obvious, innovations than this. The two theses which we have looked at already – that beauty is grounded in the form of

[20] See F.-M. Henquinet, 'Un Brouillon autographe de S. Bonaventure sur le commentaire des sentences', *Études Franciscains*, XLIV (1932), pp. 633–55, and XLV (1933), pp. 59–82. The quotations given here are taken from LB.

[21] J. Maritain, *Art and Scholasticism*, translated by J. F. Scanlan (London, 1930), p. 132, n. 63b.

the object, and that beauty is defined in relation to the knowing subject – were subsequently developed, the first by Albertus Magnus. In his Commentary on the fourth chapter of the *De Divinis Nominibus* (long attributed to Aquinas under the title *De Pulchro et Bono*), Albertus wrote, 'everything that actually exists participates in the beautiful and the good'.[22] This is to say that beauty is transcendental. But he then proceeded to give to the notion of beauty an Aristotelian foundation. After a restatement of the doctrine of the *Summa* of Alexander, that 'the beautiful and the good are the same in the subject . . . but differ logically [*ratione*]. . . . The good is distinguished from the beautiful by intention [*intentione*]', he then gives his famous definition of beauty: 'The nature of the beautiful consists in general in a resplendence of form, whether in the duly-ordered parts of material objects, or in men, or in actions.' It is clear that beauty is attributed here to all things. But more than this, beauty is guaranteed by metaphysics, not by mere lyrical excitement. Beauty exists in a thing as the splendour of its form, the form which orders the matter according to canons of proportion, and which in shining forth reveals the ordering activity. 'Beauty', he writes, 'does not subsist in material parts, but in resplendence of form'. And in consequence:

> Just as corporeal beauty requires a due proportion of its members and splendid colours . . . so it is the nature of universal beauty to demand that there be mutual proportions among all things and their elements and principles, and that they should be resplendent with the clarity of form.

What we find here is that empirical conceptions of beauty handed down in cultural tradition are synthesised in an exact and rigorous philosophical definition of beauty. This kind of hylomorphic doctrine also encompasses the various triads that originated in the Book of Wisdom: terms like *dimension*, *species* and *order*, or *number*, *weight* and *measure*, can now be predicated of form. For, if perfection, beauty, and goodness are grounded in form, any object possessing these attributes must possess all of the properties that pertain to

[22] For this and the following quotations, see Albertus Magnus, *De Pulchro et Bono*, in St. Thomas Aquinas, *Opera Omnia*, edited by Roberto Busa, 7 vols. (Stuttgart, 1980), VII, pp. 43-7.

form. Form is determined by its dimension or quantity (*modus*) and thus by *proportion* and *measure*. Form assigns a thing to its *species*, in accordance with its *number*, that is, its constituent elements in their concretion. Form directs a thing to its proper end, the one appropriate to its *order*, and to which it inclines by its *weight*.

It was a sophisticated and articulate theory. But what Albertus did not concede was that the relation of an object to the knowing subject might be a constitutive element in its beauty. His aesthetics, unlike that of the *Summa* of Alexander, was rigorously objectivist. In one place he rebutted Cicero's view that beauty should be defined with reference to people's conception of it.[23] Virtue, he said, possessed a clarity (*claritas*) which made it beautiful even if it was not known to anyone. Form was determined by clarity – not by how it is thought of, but by the splendour which inheres in it. Of course, beauty is an object of knowledge because of this clarity or splendour; but the knowledge is a derivative possibility, not an essential constituent.

The distinction involved here is far from trivial. Yet behind this kind of objectivism there is another kind. For Albertus, beauty is objectively present in things without the help or hindrance of men. The other kind of objectivism considers beauty to be a transcendental property also, but a property which is disclosed in relation to a knowing subject. This is St. Thomas Aquinas's kind of objectivism. It represents a substantial move in the direction of humanism.

Aquinas did not set out, deliberately and with full critical consciousness, to develop an original theory of beauty. But the way in which he gathered and absorbed all the traditional doctrines into his own system certainly gives this impression. It is instructive to compare the Scholastic systems – and Aquinas's system is without doubt the most comprehensive and mature – to computers; for when all the data have been fed in, every question necessarily receives a complete answer. The answer is complete only within the limits of a specific logic and a specific mode of understanding things – a medieval *Summa* is, so to speak, a medieval computer. But the point is that the system produces concepts and answers questions even in cases where its author was unaware of all of the implications of his ideas.

The medieval aesthetic tradition produced a number of theories,

[23] Albertus is presumably referring here to Cicero's *De Officiis*, I, 27, §95.

such as the mathematical conception of beauty, the aesthetic metaphysics of light, a certain psychology of vision, and a conception of form as the cause and the effulgence of pleasure. By following through these theories as they were developed, discussed, and reappraised, we will come to understand better the degree of maturity which they achieved in the thirteenth century, and to see how all the diverse problems and solutions possessed a type of systematic unity.

III. The Aesthetics of Proportion

1. 'WHAT is beauty of the body? A harmony of its parts with a certain pleasing colour.'[1] This was St. Augustine's formulation of a theory which was of central importance in the Middle Ages. It is not very different from Cicero: 'In the body a certain symmetrical shape of the limbs combined with a certain charm of colouring is described as beauty.'[2] Thus did he sum up the Stoic and Classical tradition embodied in the phrase χρῶμα καὶ συμμετρία.

The most ancient and best established concept in this aesthetic was that of 'congruence' (*congruentia*), of proportion or number, a concept whose lineage went back to pre-Socratic times.[3] It expressed an essentially quantitative conception of beauty, which cropped up again and again in Greek thought – in Pythagoras, in Plato, in Aristotle – and received its classical formulation in the canon of Polyclitus, and in Galen's subsequent exposition of Polyclitus's doctrines.[4] The canon of Polyclitus itself had been concerned largely with practical, technical issues, but it was drawn into the current of Pythagorean speculation, and ended up buttressing a dogmatic philosophy of art and beauty. The only extant fragment from it is the proposition

[1] St. Augustine, Letter 3 (to Nebridius), *Letters*, vol. 1, translated by Sister Wilfred Parsons (Washington, 1951), pp. 6–11 (p. 9).
[2] Cicero, *Tusculan Disputations*, translated by J. E. King (London and Cambridge, 1950), IV, 13.
[3] 'Order and proportion are beautiful and useful', H. Diels, *Die Fragmente der Vorsokratiker*, 6th edition (Berlin, 1951–2), I, 469.
[4] For a discussion of Polyclitus and Galen, see Erwin Panofsky, *Meaning in the Visual Arts* (Harmondsworth, 1970), pp. 90–100

that 'the beautiful comes about, little by little, through many num-
bers'.[5] Galen, in his summary of the canon, defined beauty as
follows. 'Beauty does not consist in the elements, but in the har-
monious proportion of the parts, the proportion of one finger to the
other, of all the fingers to the rest of the hand . . . of all parts to all
others, as it is written in the canon of Polyclitus.'[6] This line of think-
ing generated a simple and universal aesthetic theory, one that
articulated a formal, almost mathematical concept of beauty. Its
many variations are reducible to the one fundamental principle of
unity in variety.

The other source of the medieval theory of proportion was Vitru-
vius. From the ninth century onwards, Vitruvius was constantly
cited in philosophical and technical manuals alike. He supplied them
with a vocabulary – terms like 'proportion' and 'symmetry' – and
also with a number of formulations of the aesthetics of proportion.
For instance, 'Proportion consists in taking a fixed nodule, in each
case, both for the parts of a building and for the whole'; or again, he
defines proportion as 'the appropriate harmony arising out of the
details of the work itself; the correspondence of each given detail
among the separate details to the form of the design as a whole'.[7] In
the thirteenth century Vincent of Beauvais developed the Vitruvian
theory of the proportions of the human figure in his *Speculum Natu-
rale*.[8] This work is rather Greek in spirit, for it is a collection of rules,
according to which the dimensions of a beautiful object are deter-
mined by the relations among themselves, rather than their relations
to an abstract numerical unity. For instance, the face is said to be one
tenth of the size of the body. Proportion is here conceived of, not as
something grounded in abstract number alone, but as an organic and
concrete harmony.

It was from these sources, then, that the theory of proportion
descended to the Middle Ages. At the borders between the classical
and the medieval worlds we find St. Augustine and Boethius. Both

[5] Erwin Panofsky (1970), p. 96.

[6] Erwin Panofsky (1970), p. 92.

[7] Vitruvius, *On Architecture*, translated by Frank Granger (London, 1931–4), III, 1, 1 and I,
2, 4.

[8] Vincent of Beauvais, *Speculum Naturale*. This work and its author are discussed briefly in
H. O. Taylor, *The Medieval Mind*, 2 vols. (London, 1911), II, pp. 315–22.

of these transmitted onwards the more Pythagorean aspects of the
philosophy of proportion, for they dealt with it chiefly in the con-
text of musical theory.[9] In Boethius we find also a very typical fea-
ture of the medieval mentality: when he speaks of 'music' he means
the mathematical science of musical laws. He considered that a true
musician was a theorist, a student of the mathematical laws of sound.
Instrumentalists were unwitting servants. The composer dwelt in
the sphere of instinct, ignorant of the ineffable beauty which theory
alone can reveal: 'He is borne to song, not by speculation and reason,
but by a kind of natural instinct'.[10] The name of musician belonged
primarily to people who judged music in the light of reason. Boethius
seemed almost to congratulate Pythagoras for undertaking to study
music 'setting aside the judgement of the ears'.[11] His approach to
musical experience, and likewise the general approach of the early
Middle Ages, was that of a scientist.

Still, this very abstract concept of proportion subsequently led to
inquiries into the actual structures of sense experience, and a familiar-
ity with the creative act led to a more concrete idea of proportion. It
must also be remembered that the concept of proportion came to
Boethius from the classical tradition, so that his theories were not
just invented abstractions. The outlook of Boethius was that of a
sensitive intellectual in an age of profound crisis, an age occupied
with the destruction of seemingly irreplaceable values. The classical
world was vanishing before his eyes, the eyes of the last humanist. It
was a barbaric time, in which the cultivation of letters was dying
out. The break-up of Europe had reached one of its most tragic
moments. Boethius sought refuge by subscribing to values which
could not be destroyed: the laws of number, which would govern art
and nature no matter what came to pass. Even in moments of great-
est optimism about the beauty of the world, his outlook was that of a
sage concealing a distrust of the phenomenal world behind an
admiration for the beauty of mathematical noumena. The aesthetics

[9] In the Middle Ages, Pythagoras was regarded as the most outstanding figure in the history
of music.

[10] Boethius, *De Institutione Musica*, edited by Godofredus Friedlein (Leipzig, 1867), I, 34.

[11] *De Institutione Musica*, I, 33. However in the same place he writes, about certain musical
theories, 'I have proved all of these both by mathematics and by the judgment of the ears'.

of proportion, therefore, entered the Middle Ages as a dogma for which, it seemed, no verification was needed. But in the event, it stimulated a number of active and fruitful attempts to verify it.

The Boethian theory of music is a familiar one. Pythagoras had observed that a blacksmith's hammers struck his anvil with different notes, and that this difference was proportional to the weight of the hammers. Sound was thus governed by number, and this was so irrespective of whether sound was taken as a physical or as an artistic phenomenon. 'Consonance', Boethius wrote, 'regulates all musical modulations, and cannot exist without sound'.[12] Again, he defined consonance as 'a unified concordance of sounds dissimilar in themselves'. And it pleases the listener because 'consonance is a mixture of high and low sounds striking the ear sweetly and uniformly'.[13]

As for the aesthetic experience of music, this also was grounded in the principle of proportion. For human nature turns away from discordant modes but surrenders itself to those which are congenial. Extra support for this view came from educational theory, which held that different musical modes had differing effects upon people Some rhythms were harsh and some were temperate; some were suitable for children; some were soft and lascivious. The Spartans, Boethius reminds us, believed that they could influence their souls by music, and Pythagoras once calmed and sobered a drunken youth by making him listen to a melody in the Hypophrygian mode in spondaic rhythm; the Phrygian mode would have overexcited him. The Pythagoreans made use of certain lullabies to help them to get to sleep, and when they awoke they shook the sleep from their eyes with the help of music.

Boethius explained all of this in terms of the theory of proportion. The soul and the body, he said, are subject to the same laws that govern music, and these same proportions are to be found in the cosmos itself. Microcosm and macrocosm are tied by the same knot, simultaneously mathematical and aesthetic. Man conforms to the measure of the world, and takes pleasure in every manifestation of this conformity: 'we love similarity, but hate and resent dissimilarity'.[14]

[12] This and the following quotation are from *De Institutione Musica*, I, 3.

[13] *De Inst. Mus.*, I, 8.

[14] *De Inst. Mus.*, I, 1.

The theory of proportion in the human psyche underwent some interesting developments in medieval aesthetics, but it was the Boethian conception of proportion in the universe that caught their imagination most. One of its chief elements was the belief that there was a *musica mundana* – that is, the Pythagorean theory of a music of the spheres, a harmony produced by the seven planets orbiting around a motionless earth. According to Pythagoras, each planet generated a note of the scale, the pitch heightening according to the distance from the earth – according, that is, to the planet's velocity. Together they produced a most exquisite music, which human beings, due to the inadequacy of their senses, were unable to hear. (Jerome of Moravia drew a rather unhappy analogy with our inability to perceive the same range of smells as dogs.[15]) We can see here some of the limitations of the medieval weakness for pure theory. For of course, if each planet produced one note of the scale, together they would sound very discordant indeed. The medieval theorist refused to worry about this difficulty so long as he was convinced of the numerical correspondences. All through the Middle Ages he was to intepret his experience in terms of this Platonic type of certainty; and we may well agree that the ways of science are infinite when we recall that Renaissance astronomers were to deduce that the earth moved from the premiss that it had to do so in order to produce the eighth note and so complete the scale.

On the other hand, the theory of *musica mundana* led also to a more concrete conception of beauty – of beauty in the cycles of the universe, in the regular movements of time and the seasons, in the composition of the elements, the rhythms of nature, the motions and humours of biological life: the total harmony, in short, of microcosm and macrocosm.

The Medievals developed an infinity of variations on this theme of musical harmony of the world. In his *Liber Duodecim Quaestionum*, Honorius of Autun devoted a whole chapter to explaining 'that the universe is ordered like a cithera, in which there is a consonance of different kinds of things, like chords'.[16] And John Scotus Eriugena

[15] Jerome of Moravia, *Tractatus de Musica*, chap. 7, in *Scriptorum de Musica Medii Aevi*, edited by E. de Coussemaker, 3 vols. (Hildesheim, 1963; 1st pub. Paris, 1864–7), I, pp. 1–94 (p. 13).

[16] Honorius of Autun, *Liber Duodecim Quaestionum*, chap. 2 (PL, 172, col. 1179).

remarked that the beauty of creation was due to a consonance of similars and dissimilars, in a harmony each of whose parts in isolation was insignificant but whose creation produced the beauty of all things.[17]

2. In the twelfth century, not all speculation of this kind derived from the theory of music. The School of Chartres remained faithful to the Platonic heritage of the *Timaeus*, and developed a kind of 'Timaeic' cosmology. However, it had roots also in a partly aesthetical, partly mathematical, *Weltanshauung*. As Tullio Gregory writes:

> Their picture of the cosmos was a development, in terms of Boethius's writings on arithmetic, of the Augustinian principle that God disposes the world according to *ordo et mensura* – a principle that combines the classical concept of the cosmos as *consentiens continuata cognatio* with the principle of a Divinity who is life, providence and destiny.[18]

This vision of things had first appeared in the *Timaeus*:

> God, purposing to make it [the universe] most nearly like the every way perfect and fairest of intelligible things, fashioned one visible living creature, containing within itself all living things which are by nature of its own kind [i.e. are visible]. . . . The fairest of all bonds is that which makes itself and the terms it binds together most utterly one, and this is most perfectly effected by a progression.[19]

For the School of Chartres, the work of God was the κόσμος – the all-encompassing order, opposite of primeval chaos. Nature was the mediator of His operations; there was, as William of Conches put it, 'a certain force inherent in things, making similars out of similar things'.[20] Nature, in the Chartrian metaphysics, was not merely an allegorical personification but an active force which presided at the birth and the becoming of things. And then there was the embellishing of the world

[17] John Scotus Eriugena, *On the Division of Nature*, Book III, *passim*.
[18] Tullio Gregory, *Anima Mundi* (Florence, 1955), p. 214.
[19] Plato, *Timaeus*, 30d and 31c.
[20] William of Conches, *Dragmaticon*. Quoted in Tullio Gregory, p. 178.

(*exornatio mundi*) – the process of completing and perfecting which
Nature, in all its organic complexity, actuates in the world after its
creation. 'The beauty of the world', wrote William of Conches,
'lies in things being in their own element, such as stars in the sky,
birds in the air, fish in water, men on earth'.[21] That is, the furnishing
or fitting out of the world (*ornatus mundi*) consists in the ordering of
creation; it flourishes whenever the matter of creation begins to dif-
ferentiate itself according to weight and number, and to take on
shape and colour in its proper milieu within the universe. So, even in
a cosmological theory like this, the term *ornatus* seems to connote an
individuating structure in things. Later on, in the thirteenth cen-
tury, this concept became the foundation for a theory of beauty
centred on the notion of form. In fact, the harmony of the cosmos
looks very like an expanded metaphor for the organic perfection of
individual forms, both natural and artistic.

In this theory, the rigid logic of mathematics is tempered by a sen-
sitivity to the organic qualities of nature. William of Conches,
Thierry of Chartres, Bernard of Tours, and Alan of Lille, preferred
not to speak of an immutable mathematical order, but rather of an
organic process whose nature was best explained by reference to its
Author. The Second Person of the Trinity was the formal cause or
organising principle of this aesthetic harmony, while the Father was
its efficient cause and the Spirit its final cause, the *amor et connexio,
anima mundi*. It was Nature, not number, which governed the earth,
Nature of which Alan of Lille wrote:

> Oh child of God, mother of creation, bond of the universe and its
> stable link, bright gem of those on earth, mirror for mortals,
> light-bearer for the world: peace, love, virtue, guide, power,
> order, law, end, way, leader, source, life, light, splendour,
> beauty, form, rule of the world.[22]

In these and similar visions of cosmic harmony, many of the prob-
lems connected with negative features of the world found a solution.
Even ugliness found its place, through proportion and contrast, in

[21] William of Conches, *In Timaeum*. Quoted in Tullio Gregory, p. 213.
[22] Alan of Lille, *The Plaint of Nature*, translated by James J. Sheridan (Toronto, 1980), p.
128.

the harmony of things. It was a view common to all the Scholastics
that beauty was born out of contrasts. Even monsters acquired a cer-
tain justification and dignity from their participation in the music of
creation. Evil itself became good and beautiful, for good was born
from it and shone out more brightly by contrast.

3. The twelfth century, then, developed and systematised ideas
drawn from Pythagorean cosmology. And in so doing it came up
with yet another theory, that of *homo quadratus* (literally 'squared
man'). In origin it was connected with Chalcidius and especially
Macrobius, who wrote that 'the world is man writ large and man is
the world writ small'.[23] The medieval love of allegory was here
enriched by an account of the relation between microcosm and mac-
rocosm which was couched in terms of mathematical archetypes.
According to the theory of *homo quadratus*, number is the principle of
the universe, and numbers possess symbolical meanings which are
grounded in correspondences at once numerical and aesthetic. Initially
the theory referred to music. Thus, an anonymous Carthusian monk
said that there were eight musical tones, four discovered by the
ancients and four more added in modern times:

> For they [the ancients] argued in the following way. As it is in
> nature, so it ought to be in art: but nature divides itself in a quad-
> rapartite manner . . . There are four regions of the earth, four ele-
> ments, four primary qualities, four winds, four conditions of the
> body, four virtues of the soul and so on.[24]

It was commonly believed, in fact, that the number four had some
kind of fundamental significance. There were four cardinal points,
four winds, four phases of the moon, four seasons, four letters in the
name 'Adam', and four was the constitutive number of Plato's tetra-
hedron, which corresponded to fire. Vitruvius taught that four was
the number of man, because the distance between his extended arms
was the same as his height – thus giving the base and height of a

[23] Macrobius, *Commentary on 'The Dream of Scipio'*, translated by W. H. Stahl (New York, 1952), II, 12.
[24] *Tractatus de Musica Plana*, chap. 2, in E. de Coussemaker, II, pp. 434–83 (p.435).

square. Four was the number of moral perfection, and men experi-
enced in the struggle for moral perfection were called 'tetragonal'.
However, *homo quadratus* was also pentagonal, for five was another
number of arcane significance which symbolised mystical and aesthe-
tic perfection. Five was a circular number. There were five essences
of things, five elementary zones, five genera of living creatures (birds,
fish, plants, animals, men). Five was the number of Divinity, and was
scattered throughout the Scriptures (the Pentateuch, the five
wounds). The number five was found in man, for if the extremities of
his body were joined by straight lines they formed a pentagon (an
image found in Villard de Honnecourt, and also in the much better-
known drawing by Leonardo). The mysticism of St. Hildegard was
based upon the symbolism of proportion and the mysterious fascina-
tion of the pentad. It was she who spoke of the 'symphonic' organis-
ation of nature, and of how the experience of the Absolute unfolded
in the manner of music. Hugh of St. Victor said that body and soul
reflected the perfection of the divine beauty, the body being founded
on even numbers, imperfect and unstable, and the soul on odd num-
bers, stable and perfect. The spiritual life, he added, is based on a
mathematical dialectic which is founded in turn upon the perfection
of the number ten.[25]

This 'aesthetics of number' can be clarified further by reference to
something which has been at times misunderstood. The use of the
expression 'tetragonal', to indicate moral rectitude, reminds us that
the harmony of uprightness or probity (*honestas*) was interpreted,
allegorically, as a numerical harmony, and more critically as the pro-
portion between an action and its end. Thus the Medievals have been
accused of reducing the beautiful to the useful or the moral. How-
ever, the notion of ethical perfection that emerges from this com-
parison of microcosm and macrocosm is in fact aesthetic in character.
Far from reducing the aesthetic to the ethical, the Medievals gave
moral values an aesthetic foundation. Though even this is to an
extent misleading, since number, or order or proportion, is as much
ontological as it is ethical and aesthetic. Aesthetic qualities predomi-
nate if one adopts a contemplative perspective on something, rather
than an active role; although contemplation is always 'mixed' or

'impure' because of the close integration of values. Point of view was the important thing. Here is Vincent of Beauvais:

> Verily how great is even the humblest beauty of this world, and how pleasing to the eye of reason diligently considering not only the modes and numbers and orders of things, so decorously appointed throughout the universe, but also the revolving ages which are ceaselessly uncoiled through abatements and successions, and are marked by the death of what is born. I confess, sinner as I am, with mind befouled in flesh, that I am moved with spiritual sweetness towards the creator and ruler of this world, and honour Him with greater veneration, when I behold at once the magnitude, and beauty and permanence of His Creation.[26]

Vincent of Beauvais takes us to the thirteenth century, however. By this time, cosmological aesthetics had already become more concrete in an aesthetics of form. The concept of proportion expanded in scope and the Scholastics, especially St. Bonaventure, were compelled by their systematic principles to return to an Augustinian formula: that of a numerical balancing or equilibrium (*aequalitas*); or, more simple, unity in variety.

4. The aesthetics of proportion began with the musical theories of late antiquity and the early Middle Ages, and as it developed it assumed ever more complex forms. It also drew closer to everyday artistic practices. In musical theory, the concept of proportion began to assume technical overtones; even as early as the ninth century we find the first philosophical discussion of counterpoint.[27] However, historians of music have begun to realise that what was employed here was not the general concept of proportion, but certain specific proportions. Round about the year 850, hymns of rejoicing based upon the alleluia refrain began to feature the use of trope: each syllable was made to correspond with a new phrase of the melody. Inevitably, this led people to think about music in terms of proportion. Diastema was invented in the tenth century – that is, indicating the

[26] Quoted in H. O. Taylor, *The Medieval Mind*, II, pp. 347–8.
[27] See the anonymous *Tractatus de Musica* in E. de Coussemaker, II, pp. 251–81.

pitch of notes (or neumes) by vertical placing on the page. In the eleventh century we find that the two voices in diaphony, no longer in unison, each follows its own melodic line. Diaphony led to descant, and this in turn to the great twelfth century inventions in polyphony. In an organum by Pérotin there might be a complex movement built upon a single generating base note, like the soaring spires of a Gothic cathedral. Thus did the medieval musician give a significance to the concepts of antiquity which is concrete indeed beside the Platonic abstractions of Boethius. Harmony, a 'fitting union of different sounds' (*diversarum vocum apta coadunatio*[28]), had become a technical aesthetic value realised in lived experience: 'Whosoever wishes to compose a *conductus** must first find a canto, the most beautiful that he can. Then he must use it to construct a descant.'[29] A metaphysical principle had become an artistic one. The view that the metaphysics of beauty and the theory of art never overlapped is wrong.

Literature also abounded with precepts that involved the concept of proportion. Geoffrey of Vinsauf, in *Poetria Nova*, said that literary ornament was governed by decorum; and decorum was a qualitative rather than a numerical notion, grounded in phonetic and psychological requirements. Thus, it was decorous or fitting to describe gold as *fulvum*, milk as *nitidum*, the rose as *praerubicunda*, honey as *dulcifluum*.[30] The style, in short, should suit the subject-matter. The concept of decorum gave rise to theories of descriptive similes. And there were rules to be followed also when writing both about the natural order and about the eight species of the artificial order. It was a poetics expounded by a number of authors, and as Edmond Faral comments, 'They knew, for instance, what effects they could achieve by the symmetry of diptychs and triptychs; they knew how to suspend the course of the narration, and how to connect a number

* Medieval composition for two or three parts, distinguished from the Motet in being homophonic, not polyphonic, in style.

[28] Hucbald of Saint-Amand, *Musica Enchiriadis*, chap. 9, in *Scriptores Ecclesiastici de Musica Sacra Potissimum*, edited by Martin Gerbert, 3 vols. (Hildesheim, 1963; 1st pub. St. Blasien, 1784), I, pp. 152–212 (p. 159).

[29] Franco of Cologne, *Ars Cantus Mensurabilis*, chap. 11, in E. de Coussemaker, I, pp. 117–36 (p. 132).

[30] Geoffrey of Vinsauf, *The New Poetics*, translated by Jane Baltzell Kopp, in *Three Medieval Rhetorical Arts*, edited by James J. Murphy (Berkeley, Los Angeles, London, 1971), See in particular p. 61.

of themes that were being unfolded simultaneously'.[31] Many of the
medieval romances followed these rules: the aesthetic principle had
turned initially into a methodology of poetics, and then into a real
technique. And at the same time the opposite process was taking
place – that is, theory was moving closer to experience. One com-
mon literary principle in the Middle Ages was that of brevity. It was
recommended by Alcuin, for instance, in his *De Rhetorica*,[32] and
meant in effect the excision of anything superfluous. Nowadays we
might speak of what is 'appropriate' in connection with the con-
struction of imaginative literature; the medievals spoke instead of
'proportion', and thus tend to confuse us by their use of a word
overloaded with meanings.

Turning next to the plastic and figurational arts, we find again that
the concept of symmetry was very common, due mainly to the influ-
ence of Vitruvius. Vincent of Beauvais, following in his footsteps,
wrote that architecture consists of order, disposition, eurhythmy,
symmetry and beauty.[33] The principle of proportion was also the
basis for a kind of heraldic symbolism employed in architectural prac-
tice. This was an esoteric business, a kind of mysticism of propor-
tion. It began with the Pythagoreans, and although it was exorcised
by Scholasticism it lived on in artisan circles as a kind of heraldry,
used to give an extra importance to the trade and to preserve its rites
and secrets. This is the most likely explanation for the frequency of
pentagonal motifs in Gothic art, especially rose ornaments in cathe-
drals. The five-petalled rose was an image of the pentad, in addition
to its many other symbolic meanings in medieval times, from the
Romance of the Rose to the Wars of the Roses. It would be quite
wrong to look upon every representation of the pentad as a mark of
some esoteric religion, but it certainly bore witness to an aesthetic
principle or ideal. The masonic guilds used it as the basis of their
rituals, and this seems to show again an awareness of a connection
between craft and the aesthetic.

We find the same kind of thing in the geometrical marks used by
artisans as their 'signatures'. Studies of the *Bauhütte*, the secret society

[31] Edmond Faral, *Les Arts poétiques du XIIe et du XIIIe siècle* (Paris, 1924), p. 60.

[32] Alcuin, *Dialogus de Rhetorica et Virtutibus* (PL, 101, cols. 919–50).

[33] Vincent of Beauvais, *Speculum Doctrinale*, XI, 12, 14.

of master masons, stonecutters and carpenters in the Holy Roman Empire, show that their *signa lapidaria* – that is, the personal signs with which they marked important parts of their works, such as cornerstones – were geometrical marks based upon common master keys or 'grids'. The underlying belief was that locating the centre of symmetry meant locating the way, the truth, and the light. Aesthetic custom and theological doctrine went hand in hand. The aesthetics of proportion was the medieval aesthetic *par excellence*.

The principle and criterion of symmetry, even in its most elementary forms, was rooted in the very instincts of the medieval soul. It had an influence even upon medieval iconography. This iconography derived from the Bible and the Liturgy, and from the so-called *exempla praedicandi**. But often enough the requirements of symmetry modified the tradition, violating even the most ingrained beliefs and the most sacrosanct details. Thus, in a painting in Soisson we find that one of the Magi is omitted because a third figure would have destroyed the balance of the composition. Similarly, in Parma Cathedral we find St. Martin dividing his cloak with two beggars instead of one. In San Cugat del Vallés, in Catalonia, there are two Good Shepherds instead of one. Similar formal considerations are found to account for two-headed eagles and two-tailed mermaids.[34] The demands of symmetry, in short, helped to determine the repertoire of symbols.

Another somewhat similar law to which medieval art was subject was that of the 'frame'. For instance, a certain figure would have to be fitted into the shape of a door column, or the lunette on a tympanum, or the trunk of a capital. Sometimes the figures acquired an added grace from their very circumscription; thus, in the medallions representing the months on the facade of St. Denis, peasants who are harvesting grain appear, due to the circular composition, to perform a kind of dance. Or they might acquire an added expressiveness, like the sculptures on the doorway of St. Mark in Venice. Or again, the result might be romantic and grotesque, as in the vigorous and contorted figures on the candelabrum in St. Paul Without the Walls.

* Stories used in sermons to illustrate or drive home a point. In the Middle Ages many of these were circulated in anthologies known as *Libri Exemplarum*.

[34] See Louis Réau, 'L'Influence de la forme sur l'iconographie de l'art médiévale', in *Formes de l'art, formes de l'esprit*, by various authors (Paris, 1951).

There was in fact a circle of inextricable causes and effects, theoretical precepts interacting with artistic practices and habits of composition. It is interesting to see how many features of medieval art, whether stylised and heraldic or hallucinatory and deformed, originated in the demands of form rather than expression. And this was no accident. Indeed it may well have been in the forefront of artists' intentions and concerns, for medieval theories of art are invariably theories of formal composition, not of feeling and expression.

All of the medieval treatises on the figurative arts[35] reveal an ambition to raise them to the same mathematical level as music. In these treatises, mathematical conceptions are translated into canons of practice and rules of composition, usually detached from the matrix of cosmology and philosophy, though united to them nevertheless by subterranean currents of taste and preference. A useful illustration of this point is the *Album* or *Livre de portraiture* of Villard de Honnecourt.[36] In this work, all the representations of the human figure are laid out geometrically. The aim is not to present them in an abstract and stylised manner, but rather to show how to endow the human figure with life and movement. The figures are Gothic in conception, yet they illustrate a return of rules of proportion and echo the Vitruvian theory of the human body. And in the last analysis, Villard's geometrical schemas of the human figure – which, to repeat the point, are meant to serve as guidelines and norms for lively and realistic drawing – can be regarded as a reflection of a theory of beauty. This is the theory that beauty resides in the proportion which reveals and is produced by the splendour of form, where form means the *quidditas*, the essence of things.

Once the Medievals had developed fully a metaphysics of beauty, it followed that proportion, since it was an aspect of beauty, was considered to participate in its transcendental nature. Proportion, like being, was not expressible in a single definition, but could be realised on diverse and multiple levels. Just as there were infinite ways of being, so there were infinite ways of making things in accordance with

[35] Two notable examples are the *Painter's Manual of Mount Athos*, and *Il Libro dell'Arte* by Cennino Cennini. Both are discussed briefly in Erwin Panofsky (1970), pp. 102f.
[36] *Album de Villard de Honnecourt*, edited and annotated by J. B. A. Lassus and Alfred Darcel (Paris, 1968).

proportion. This idea of proportion was a notable liberation of the concept on the theoretical level, though in fact medieval culture had already acquired an experiential knowledge of it. In music, for instance, it had been realised that once a given mode was postulated, another mode could be produced simply by sharpening or flattening certain notes. Or a simple reversal of the Lydian mode would produce the Dorian mode. Or we may take the case of musical intervals. As early as the ninth century, Hucbald of Saint-Amand recognised that the fifth was an imperfect consonance; yet in the twelfth century the rule books were still referring to it as a perfect consonance. In the thirteenth century, the third joined the rank of recognised consonances. We can see therefore that the Medievals understood proportion in the context of experience, in the progressive acquisition of new types of correspondence that they found to be enjoyable and appropriate.

The same thing is to be found in literature. As early as the eighth century, Bede, in his *Ars Metrica*, formulated a distinction between metre and rhythm, a distinction as it happens between quantitative and syllabic verse. He declared that each of these poetic modes possessed its own distinctive type of proportion.[37] In succeeding centuries several authors repeated this.[38] When, eventually, all of these experiences had been homologised in a theological metaphysics, the concept of proportion was able to sustain more complex determinations, as we shall see when we come to the Thomistic theory of form.

Still, the aesthetics of proportion always remained a quantitative aesthetics. It could never explain satisfactorily the medieval pleasure in light and colour, which was a *qualitative* experience.

[37] See George Saintsbury, *A History of Criticism*, 3 vols. (London, 1900), I, p. 404.
[36] Two ninth-century examples were Aurelianus Reomensis and Remigius of Auxerre. See Martin Gerbert, I, pp. 23 and 68.

IV. The Aesthetics of Light

1. IN his *De Quantitate Animae*, St. Augustine gives a theory of beauty based upon geometrical regularity. Equilateral triangles, he says, are more beautiful than scalene triangles because of their greater 'evenness' (*aequalitas*). Squares are more beautiful still. Most beautiful is the circle, which has no angles to disrupt the continuous equality of its circumference. Above all of these, however, is the point – indivisible, centre and beginning and end of itself, the generating point of the circle, the most beautiful of all the figures.[1]

This kind of theory tended to connect the concept of proportion with the metaphysical emotions elicited by the absolute identity of God. St. Augustine's discussion of the geometrical figures is in fact part of a discussion of the 'centrality' of the soul. But this association of proportion, which is multiple, with the indivisible perfection of God, contained the seeds of a contradiction; a contradiction, which medieval aesthetics was called upon to resolve, between an aesthetics of quantity and an aesthetics of quality.

The most obvious symptom of qualitative aesthetic experience was the medieval love of light and colour. Quite a number of interesting writings provide evidence of this feeling, and they reveal something quite contrary to the aesthetic tradition which we have examined in previous chapters. We have seen how medieval theorists looked upon beauty as something intelligible, a kind of mathematical quality, even when they were discussing purely empirical matters such as the experience of metre or the design of the human body. But when

[1] St. Augustine, *The Greatness of the Soul*, translated by W. H. Stahl (New York, 1952), chaps. 8–11.

it came to their experience of colour – of gems, materials, flowers, light, and so on – the Medievals revealed instead a most lively feeling for the purely sensuous properties of things. Their love of proportion was expressed initially as a theoretical doctrine, and was only gradually transferred to the sphere of practice and precept. Their love of colour and light, by contrast, was a spontaneous reaction, typically medieval, which only afterwards came to be expressed scientifically within their metaphysical systems.[2] The beauty of colour was everywhere felt to be beauty pure and simple, something immediately perceptible and indivisible, and with no element of the relational as was the case with proportion.

Immediacy and simplicity characterised the medieval love of light and colour. The figurative art of the period shows quite a different colour consciousness from that of succeeding centuries. It confined itself to simple and primary colours. It had a kind of chromatic decisiveness quite opposed to *sfumatura*. It depended on a reciprocal coupling of hues that generated its own brilliance, and not on the devices of *chiaroscuro*, where the hue is determined by light and can even spread beyond the edges of the design. In poetry, too, colours were always decisive, unequivocal: grass was green, blood red, milk snowy white. There were superlatives for every colour – for example, *praerubicunda* for roses – and while a colour might have many shades, it was never allowed to fade and blur into shadows. Medieval miniatures testify to this love of the integral colour, to the vivacity of chromatic combinations. We find it not only in the mature works of the Flemish and Burgundians – one thinks of the *Très riches heures du duc de Berry* – but also in earlier works such as the eleventh-century miniatures of Reichenau: 'Set off by this all-pervading golden sheen, such eminently cool, bright hues as lilac, sea-green, sand-yellow, pink and bluish-white (characteristic of Reichenau miniatures) seem to shine with their own light.'[3] And there is literary evidence of the connection between the lively visual imagination of the poet and that of the painter, in Chrétien de Troyes's *Erec et Enide*:

[2] In the writings of the mystics, however, and those of the neo-Platonists in general, light was always a metaphor for spiritual realities.

[3] André Grabar and Carl Nordenfalk, *Early Medieval Painting, from the Fourth to the Eleventh Century*, translated by Stuart Gilbert (Skira, 1957), p. 206.

The one who went at her behest came bringing to her the mantle and the tunic, which was lined with white ermine even to the sleeves. At the wrists and on the neck-band there was in truth more than half a mark's weight of beaten gold, and everywhere set in the gold there were precious stones of divers colours, indigo and green, blue and dark brown . . . The mantle was very rich and fine: laid about the neck were two sable skins, and in the tassels there was more than an ounce of gold; on one a hyacinth, and on the other a ruby flashed more bright than burning candle. The fur lining was of white ermine; never was finer seen or found. The cloth was skilfully embroidered with little crosses, all different, indigo, vermilion, dark blue, white, green, blue, and yellow.[4]

Of course, this is not the only evidence of *suavitas coloris*. A search through medieval literature, both in Latin and in the vernacular, would yield an innumerable harvest. Dante writes of the *dolce colore di oriental zaffiro*; Guinizelli of the *viso di neve colorato in grana*. The *Chanson de Roland* gives us Durandal, *clère et blanche*, who shines and flames against the sun. Such examples are endless.[5] Also, it was the Middle Ages which developed an art form in which, to an unsurpassed degree, the brilliance of simple colours is married to the brilliance of light: the stained glasswork in Gothic cathedrals. But the love of colours was widely evident also in everyday life, in clothing, ornament, and weapons. In a fascinating account of the late medieval sensitivity to colour, Huizinga records the enthusiasm of Froissart for 'the splendours of a decked-out fleet, with its streamers, gay with blazonry, floating from the mast-heads, and some reaching to the water'.[6] Or the passage in *Le Blason des couleurs* which praises the conjunction of pale yellow and blue, of orange and white, orange and pink, pink and white, and black and white. And there is a passage in Olivier de La Marche which describes a lady dressed 'in violet-coloured silk on a hackney covered with a housing of blue silk, led by three men in vermilion-tinted silk and in hoods of green silk'.[7]

[4] Chrétien de Troyes, *Arthurian Romances*, translated by W. W. Comfort (London, 1914), p. 21.

[5] Many examples from French and Provencal poetry are given in ET, III, p. 9f.

[6] J. Huizinga, p. 237.

[7] J. Huizinga, p. 259.

These references to popular taste are necessary if we want to fully understand medieval theories about colour as a source of beauty. The popular love of colour was deep-rooted and essential, and if we ignore it we will be tempted to think that statements such as, 'Things are called beautiful when they are brightly coloured',[8] are puerile and superficial. On the contrary, this is a case where the philosopher had been influenced by the sensibility of his time. In the same way, Hugh of St. Victor said that green was the most beautiful of all colours, a symbol of Spring and an image of rebirth.[9] It is true that there was an element of mysticism in this, but that does not negate the element of sensuous pleasure. William of Auvergne advanced the same view, but he supported it with an argument based on psychology: green, he said, lies half way between white, which dilates the eye, and black, which makes it contract.[10]

Apart from single colours, however, philosophers and mystics alike were enthralled by luminosity in general, and by the sun's light. Medieval literature is filled with joyous acclaim of the effulgence of daylight and of fire. A basic structural principle of Gothic cathedrals was that they should give the effect of light erupting through an open fretwork. It was of this marvellous, uninterrupted transparency that Suger wrote when praising his church in one of his *versiculi*:

> The church shines with its middle part brightened.
> For bright is that which is brightly coupled with the bright,
> And bright is the noble edifice which is pervaded by new light.[11]

As for poetry, it suffices to mention Dante's *Paradiso*. It is a perfect exemplar of the love of light: in part an expression of medieval spontaneity – the medievals often conceived of God in terms of light, and regarded light as the original metaphor for spiritual realities – and in part influenced by a patristic Scholasticism.[12] The prose of the mystics was similar. On the one hand Dante could write,

[8] S.T., I, 39, 8.

[9] Hugh of St. Victor, *De Tribus Diebus*, chap. 12 (PL, 176, col. 821. The treatise is given here as Book VII of *Didascalicon*.).

[10] ET, III, p. 86.

[11] Erwin Panofsky (1946), p. 22.

[12] See Giovanni Getto, 'Poesia e Teologia nel *Paradiso* di Dante', in *Aspetti della Poesia di Dante* (Florence, 1966), pp. 193–235.

Ed ecco intorno, di chiarezza pari,
nascere un lustro sopra quel che v'era,
per guisa d'orizzonte che rischiari.

[And lo! all around me, equal in all its parts,
a splendour dawned above the splendour there
like a horizon when the new day starts.][13]

And on the other, St. Hildegard wrote,

I am that living and fiery essence of the divine substance that
glows in the beauty of the fields. I shine in the water, I burn in the
sun and the moon and the stars.[14]

The image of God as light had an ancient pedigree, from the Baal
of Semitic paganism, from the Egyptian Ra, from the Persian Mazda
– all personifications of the sun or of the sun's beneficent action – to
the Platonic 'Sun' of the Ideal, the Good. This image passed on to
neo-Platonism, Proclus in particular, and entered the Christian tradi-
tion through Augustine, and then through the Pseudo-Dionysius
who constantly praised God as *lumen*, fire, or the fount of light. Yet
another influence on later Scholastics was that of Arab pantheism –
Avenpace, Hay ben Jodkam, Ibn Tofail – which passed on its visions
of glittering essenccs of light, its ecstasies of brightness and beauty.[15]

2. The medieval love of colour was reflected both in metaphysical
metaphors and in everyday life. They were well aware, however,
that this qualitative conception of beauty was not wholly reconcil-
able with the notion that beauty was grounded in proportion. The
difference had already manifested itself in St. Augustine, and he had
undoubtedly noticed the same thing in Plotinus. Conflict could be
avoided so long as the pleasure caused by colour remained uncritical,
so long as the use of light metaphors remained within the ambit of

[13] Dante, *Il Paradiso*, XIV, 67–9, translated by John Ciardi, *The Divine Comedy* (New York
and London, 1970).
[14] Quoted in Charles Singer, ed., *Studies in the History and Method of Science* (Oxford, 1917),
p. 33.
[15] See M. Menéndez Y Pelayo, *Historia de las Ideas Estéticas en España* (Madrid, 1890), I,
chap. 3.

mysticism, and of pleasant but poorly defined cosmologies. And there was yet another problem for thirteenth century Scholastics. They had received their conceptions of light from many sources, all heavily impregnated with neo-Platonism; but they developed the philosophy of light in two ways – as a kind of physico-aesthetical cosmology, and as an ontology of form. The first of these paths was taken by Grosseteste and St. Bonaventure; the second was taken by Albertus Magnus and St. Thomas Aquinas.

Neither development was an accident. The polemic against Manicheism sparked them off. Another factor was the maturing of a new scientific mind, which provided the discussion with a range of scientific material from, in particular, the field of optics. This was the century of Roger Bacon, who proclaimed that the new science of optics was destined to solve all problems. In the *Roman de la rose*, which was a kind of allegorical compendium of the most progressive Scholasticism, Jean de Meun wrote at length about the wonder of rainbows and the marvels of curved mirrors – giants and dwarfs inverted in size and their shapes distorted. The poem refers to Alhazen as the foremost authority on the subject; and in fact, Alhazen's *De Aspectibus* or *Perspectiva* was the source of much medieval thinking on light. The work dates from the late tenth or early eleventh century, and its theses were taken up by Witelo in the thirteenth century, first in his *De Perspectiva* and then in the *Liber de Intelligentiis* (long attributed to Witelo but now to one Adam Pulchrae Mulieris). These works will be of great importance when we discuss the medieval psychology of aesthetic perception. However, the person who adapted the theory of light to the purposes of metaphysics and aesthetics was Robert Grosseteste.

In his early works, Grosseteste had developed an aesthetics of proportion. In fact we are indebted to him for one of the best formulations of this conception of beauty: 'For beauty is a concordance and fittingness of a thing to itself and of all its individual parts to themselves and to each other and to the whole, and of that whole to all things.'[16] But in his later works he took up the notion of light, and in his *Hexaemeron* he tried to resolve the conflict between the qualitative and the quantitative conceptions of beauty. He defined light as

[16] Robert Grosseteste, *Comm. in Div. Nom*. Quoted in LB.

the greatest and best of all proportions, as proportionate with itself so to speak: 'Light is beautiful in itself, for its nature is simple and all things are like to it. Wherefore it is integrated in the highest degree and most harmoniously proportioned and equal to itself: for beauty is a harmony of proportions.'[17] Thus identity was the proportion *par excellence*, and was the ground of the indivisible beauty of God, fount of light; 'for God is supremely simple, supremely concordant and appropriate to Himself'.[18]

Grosseteste here led the way, to a greater or lesser degree, for all of the Scholastics of the time, from St. Bonaventure to St. Thomas. But his own particular theory was especially personal and complex. As a neo-Platonist he insisted on the fundamental nature of light: he made it the image for a universe shaped by a unique flux of light-giving energy, at once the source of beauty and of being. It was next door to Emanationism. Out of the unique Light, progressively condensing and diminishing, came the astral spheres and the elements of nature, and thence the infinite gradations of hue and the volumes and activities of things. Thus proportion was just the mathematical order of light – diffusing itself creatively, becoming material in all the diversity imposed upon it by the resistance of matter. 'Corporeity, therefore, is either light itself or the agent which performs the aforementioned operation and introduces dimensions into matter in virtue of its participation in light, and acts through the power of this same light.'[19] Thus, at the origins of a cosmic order of the type described in the *Timaeus* there was an almost Bergsonian flux of creative energy. 'Light of its very nature diffuses itself in every direction in such a way that a point of light will produce instantaneously a sphere of light of any size whatsoever, unless some opaque object stands in the way.' And to perceive the created world was to perceive its beauty also, whether in its proportions as known to analysis, or in the immediacy of light.

St. Bonaventure's metaphysics of light was based on similar premisses. But his explanation of its nature and its creativity was allied more to Aristotle's hylomorphism. Bonaventure considered light to

[17] Robert Grosseteste, *Comm. in Hexaemeron*. Quoted in LB.

[18] *Comm. in Div. Nom*. Quoted in LB.

[19] This and the following quotation are from Robert Grosseteste, *On Light*, translated by Clare C. Riedl (Milwaukee, 1942), p. 10.

be the substantial form of bodies in so far as they were bodies, the
first determinacy assumed by matter as it comes into being: 'Light is
common by nature to all bodies, celestial and terrestrial . . . Light is
the substantial form of bodies; by their greater or lesser participation
in light, bodies acquire the truth and dignity of their being.'[20] Light
was thus the principle of all beauty, not only because it is delightful
to the senses, but also because it is through light that all the varia-
tions in colour and luminosity, both in heaven and on earth, come
into being. Bonaventure considered light under three aspects; these
were *lux*, *lumen*, and *color* or *splendor*. *Lux* was light 'in itself', light
as the ubiquitous origin of all motion, which penetrated to the very
bowels of the earth to form its minerals and sow the seeds of its life.
Lumen was the light that travels through space, borne by a transpar-
ent medium. *Color* or *splendor* referred to light thought of as some-
thing reflected by the opaque bodies that it struck against. Strictly,
splendor was the light of luminous bodies, *color* that of terrestrial
bodies. Visible colour was born of an encounter between two types
of light – one in the opaque body, one irradiating through diapha-
nous space. The latter actualised the former. Light in its pure state
was substantial form, and thus a kind of creative force in the neo-
Platonic sense. Light as the colour or splendour of an opaque body
was accidental form. This concept owed something to Aristotelian-
ism, and was the nearest approach to hylomorphism which was open
to Bonaventure, given the framework of his thought. For Aquinas,
light was 'an active quality deriving from the substantial form of the
sun'.[21] Transparent bodies had a disposition to receive and transmit
light, and light in this way acquired a new disposition itself, a new
'luminous' state: 'the participation of *lux* in a transparent object is
called *lumen*'.[22] But for Bonaventure light, although it was physical,
was primarily and fundamentally a metaphysical reality.

There were mystical and neo-Platonic undertones in Bonaventure,
which led him to stress the cosmic and ecstatic features of the aesthe-
tics of light. His most beautiful pages on beauty are those in which
he describes the beatific vision and the glories of heaven. In the

[20] St. Bonaventure, *In II Sent.*, 13, 2, 2.
[21] S.T., I, 67, 3.
[22] St. Thomas Aquinas, *Comm. de Anima*, II, 14, 421.

resurrected bodies of mankind, light will shine out with its four fundamental characteristics: clarity which illuminates, impassibility so that it cannot corrupt, agility so that it can travel instantaneously, and penetrability so that it can pass through transparent bodies. Transfigured in heaven, the original proportions dissolved into a pure effulgence, the ideal of the *homo quadratus* returns as an aesthetic ideal in the mysticism of light.

V. Symbol and Allegory

1. THE thirteenth century saw the birth of yet another theory of beauty, one based upon hylomorphism. It was a theory which tried to incorporate the phenomenologies of physical and metaphysical beauty which were found in both the aesthetics of proportion and the aesthetics of light. However, we will understand better the conditions under which it appeared if we look first at another aspect of the medieval aesthetic sensibility. It is perhaps its most typical aspect, the one which characterises the period above all others and which we tend to look upon as uniquely medieval. This is the medieval tendency to understand the world in terms of symbol and allegory.

Huizinga gives an excellent analysis of this, and adds that it is a tendency which we continue to share even nowadays:

> Of no great truth was the medieval mind more conscious than of Saint Paul's phrase: *videmus nunc per speculum in aenigmate, tunc autem facie ad faciem.* The Middle Ages never forgot that all things would be absurd, if their meaning were exhausted in their function and their place in the phenomenal world, if by their essence they did not reach into a world beyond this. This idea of a deeper significance in ordinary things is familiar to us as well, independently of religious convictions: as an indefinite feeling which may be called up at any moment, by the sound of raindrops on the leaves or by the lamplight on a table. Such sensations may take the form of a morbid oppression, so that all things seem to be charged with a menace or a riddle which we must solve at any cost. Or they may be experienced as a source of tranquillity and assurance, by filling

us with the sense that our own life, too, is involved in this hidden meaning of the world.[1]

The Medievals inhabited a world filled with references, reminders and overtones of Divinity, manifestations of God in things. Nature spoke to them heraldically: lions or nut-trees were more than they seemed; griffins were just as real as lions because, like them, they were signs of a higher truth. Lewis Mumford has described this as a kind of neurosis[2] – a description which is certainly apposite in a metaphorical sense, for it pinpoints the element of strain and deformation in the medieval way of looking at things. More precisely, one could describe the mentality as primitive: there was a certain weakness in their capacity to differentiate among things, a tendency in their concepts to include not just the things of which they were concepts, but also things similar or related to them. Yet it was not primitism either. Rather, it was a prolongation of the mythopoeic dimension of the Classical period, though elaborated in terms of the new images and values of the Christian ethos. And again, it was a revival, caused by a new sense of the supernatural, of the sense of wonder which had faltered in late Antiquity when the gods of Lucian replaced the gods of Homer.

We could also think of the medieval propensity for myth and symbol as a flight from reality comparable to that of Boethius, but on the populist level of fable rather than on the level of theory. The 'dark ages' of the early medieval period were years of depression in city and country alike: years of war, of famine and pestilence, of early death. The neurotic terrors of the year 1000 were not as dramatic and excessive as legend would indicate, but the legend was itself born and nourished in a milieu of endemic anxiety and radical insecurity. One of the solutions devised by society to meet these problems was Monasticism, which gave birth to communities which were stable, orderly, and tranquil. The imagination, however, responded to the crisis in a different way, by developing bodies of symbols. Even at its most dreadful, nature appeared to the symbolical imagination to be a kind of alphabet through which God spoke to men and revealed the

[1] J. Huizinga, p. 194.
[2] Lewis Mumford, *The Condition of Man* (London, 1944), pp. 138f.

order in things, the blessings of the supernatural, how to conduct oneself in the midst of this divine order and how to win heaven. In themselves, things might inspire distrust because of their disorder, their frailty, their seeming hostility. But things were more than they seemed. Things were signs. Hope was restored to the world because the world was God's discourse to man.

Christian thinkers were simultaneously looking for positive justification of earthly things, at the very least as an instrument of salvation. But fables and symbols were able to articulate qualities that theory could not. And again, they could make intelligible those doctrines which proved irksome in their more abstract form. Primitive Christianity had already given symbolical expression to the principles of faith; it did this out of prudence, to avoid persecution. Jesus Christ, for example, was represented as a fish. But this opened the way for various imaginative and didactic possibilities that proved to be congenial to medieval man. On the one hand, unsophisticated persons found it easy to convert their beliefs into images; and on the other, theologians and teachers themselves constructed images for those ideas which ordinary people could not grasp in their theoretical form. There was a great campaign to educate the people by appealing to their delight in image and allegory. Suger was one of its leading advocates. And as Honorius of Autun put it, following the Synod of Arras in 1025, pictures were the literature of the laity (*laicorum literatura*).[3] In this way a theory of education attached itself to the sensibility of the time, a kind of cultural politics which sought to exploit the mental processes that typified the age.

This love of symbol had a curious effect upon the medieval way of thinking. In the normal course of events they would interpret things genetically, in terms of cause and effect. But there could also be a kind of 'short circuit' of the mind, a mode of understanding which looked upon the relations among things not as causal connections, but as a web of meanings and ends. For instance, with a sudden mental leap they would decide that white, red, and green were benevolent, while black and yellow signified penitence and sorrow. White was a symbol of light, of eternity, of purity and virginity: there was a sensitivity to quality here with which we are still in sympathy. The

[3] Honorius of Autun, *Gemma Animae*, chap. 132 (PL, 172, col. 586).

ostrich became a symbol of justice, because the perfect equality of its feathers suggested the notion of unity. The pelican, which was believed to nourish its young with its own flesh, became a symbol of Christ who had given His blood for humanity and His flesh in the Eucharist. The unicorn could be captured by a virgin if it rested its head in her lap, so it was doubly a symbol of Christ – as the Son only-begotten of God, and begotten again in the womb of Mary. Once the symbolism had been accepted, the unicorn became even more 'real' than the ostrich or the pelican.

Symbolical interpretation basically involves a certain concordance and analogy of essences. Huizinga, in fact, attempts to explain it as a capacity for thinking in terms of essences: the symbol and the thing symbolised have in common certain characteristics which can be abstracted and compared. Thus, red and white roses flourishing among thorns could being to mind the virgins and martyrs who shone forth amidst their persecutors. Roses and thorns on the one hand, martyrs and persecutors on the other: they had certain properties in common, the white of innocence, the red of blood, harshness, cruelty. Colours were in this way reduced to essences, with a distinctive and autonomous value.[4] Yet to an even greater extent, symbolical interpretation had to do with relations of decorum. The formation of symbols was artistic. To decipher them was to experience them aesthetically. It was a type of aesthetic expression in which the Medievals took great pleasure in deciphering puzzles, in spotting the daring analogy, in feeling that they were involved in adventure and discovery.

According to the Pseudo-Dionysius, it was appropriate that the things of God should be symbolised by very dissimilar entities – lions, bears, panthers – because it was precisely the incongruity of a symbol that made it palpable and stimulating.[5] *Aliud dicitur, aliud demonstratur*: the Medievals were responsive to this principle even more than we are nowadays to lyricism in poetry. Allegory, according to Bede, excites the spirit, animates the expression, and ornaments the style. We are quite justified in not sharing this taste, but we should not forget that it was to the taste of the Medievals, and that it was one of

[4] J. Huizinga, pp. 195f.
[5] Pseudo-Dionysius, *Cêlestial Hierarchy*, II.

the fundamental modes in which their aesthetic requirements were satisfied. In fact, it was a kind of unconscious striving after proportion which led to this constant effort to unite the natural and the supernatural. In a symbolical universe, everything is in its proper place because everything answers to everything else. In such a harmonious system, the serpent is homogeneous with the virtue of prudence; and yet the same serpent can symbolise Satan. It was a kind of polyphony of signs and references. Christ and His divinity were symbolised by a vast number and variety of creatures, each signifying His presence in a different place – in heaven, on mountain-tops, in the fields, the forests, and the seas. The symbols used included the lamb, the dove, the peacock, the ram, the gryphon, the rooster, the lynx, the palm-tree, even a bunch of grapes: a polyphony of images. 'About each idea other ideas group themselves, forming symmetrical figures, as in a kaleidoscope'.[6]

2. Medieval symbolism, thus, expressed an aesthetic conception of the world. There were, however, two forms of it. Firstly there was *metaphysical symbolism*, related to the philosophical habit of discerning the hand of God in the beauty of the world.[7] Secondly there was *universal allegory*; that is, perceiving the world as a divine work of art, of such a kind that everything in it possesses moral, allegorical, and anagogical meanings in addition to its literal meaning. What I have been looking at so far is in fact universal allegory.

Metaphysical symbolism had its roots in Antiquity. Macrobius wrote that the beauty of things reflected the hand of God, like a mirror.[8] Neo-Platonism in general had a similar belief, and it was John Scotus Eriugena, following the Pseudo-Dionysius, who gave to the Middle Ages the most fruitful formulation of metaphysical symbolism. For Eriugena the world was a great theophany, manifesting God through its primordial and eternal causes, and manifesting these causes in its sensuous beauties. 'In my judgment', he wrote, 'there

[6] J. Huizinga, p. 198.
[7] As Edgar de Bruyne puts it, metaphysical symbolism was 'an aesthetic expression of ontological participation'. *L'Esthétique du moyen age* (Louvain, 1947), p. 93.
[8] Macrobius, *Commentary on 'The Dream of Scipio'*, I, 14.

is nothing among visible and corporeal things which does not signify something incorporeal and intelligible.'[9] God's creative power, marvellous and ineffable, was at work in every creature; thus did He manifest and reveal Himself, though He can be known only in secret and is ultimately incomprehensible. The eternal prototypes, the immutable causes of all existence, operate in the Word. Quickened by the breath of Love, they are diffused creatively in the darkness of original chaos:

> one God, one Goodness, one Light, diffused in all things so that they may exist fully, shining in all things so that all people may know and love His beauty, dominating all things so that they may flourish in their full perfection, and so that all may be one in Him. Thus the light of all lights comes from the Father.[10]

We have merely to cast our eye upon the visible beauty of the earth to be reminded of an immense theophanic harmony, of primordial causes, of the Divine Persons. The face of eternity shines through the things of earth, and we may therefore regard them as a species of metaphor. Here we find a transition from metaphysical symbolism to cosmic allegory; in fact Eriugena contemplated such a transition. But the fundamental character of his aesthetics was determined by his capacity to study nature philosophically rather than imaginatively, to consider ontological values in the light of the theory of divine participation – as well as by his tendency to downgrade the concrete in favour of the true and unique reality of ideas. This conception of the ideal realm, as something essentially beyond our reach, unknowable in so far as it coincides with God Himself, made his aesthetics one of the most fruitful chapters in medieval Platonism. It was far removed, however, from the ontology of substantial beauty which was to originate in Aristotelian hylomorphism.

Another account of metaphysical symbolism was given in the twelfth century by Hugh of St. Victor. For him as well, the earth was 'like a book written by the finger of God' (*quasi quidam liber scriptus digito Dei*).[11] Man's sensitivity to beauty was directed ultimately at the

[9] John Scotus Eriugena, *On the Division of Nature*, V, 3.

[10] John Scotus Eriugena, *Super Hierarchiam Caelestem*, chap. 1 (PL, 122, col. 128).

[11] Hugh of St. Victor, *De Tribus Diebus*, chap. 4 (PL, 176, col. 814. See n. 9, Chapter IV above.).

discovery of intelligible beauty. The pleasures of sound and sight, of smell and touch, bring us face to face with the beauty of the world, so that we may see in it the reflection of God. In his commentary on the *Celestial Hierarchy* of the Pseudo-Dionysius, Hugh takes up the same themes as Eriugena, accentuating if anything the aesthetic implications:

> All things visible, when they obviously speak to us symbolically, that is when they are interpreted figuratively, are referable to invisible significations and statements . . . For since their beauty consists in the visible forms of things . . . visible beauty is an image of invisible beauty.[12]

His theory is more detailed than Eriugena's. He is more critical, grounding the principle of symbolism in the aesthetic concept of similitude. There is an almost Romantic sense of the inadequacy of earthly beauty, which provokes in him who contemplates it that sense of dissatisfaction which is a form of yearning for God. There are certain parallels with the modern sentiment of melancholy in the face of intense beauty; yet it is only a vague similarity of basic human attitudes, which flourished in fundamentally different cultures. The melancholy of Hugh of St. Victor was closer to the radical dissatisfaction of the mystics, which was caused by the things of earth, and it was too intense for us to interpret it as a merely intellectual rejection of the world. The Victorine aesthetic gave a symbolic value even to ugliness – here there is perhaps a kind of analogy with the Romantic sense of irony – through its dynamic conception of contemplation. For when the soul is confronted with ugliness it is unable to achieve contentment, and is freed also from the kind of illusion created by beauty. Thus it is led naturally to desire the true and immutable Beauty.

3. The passage from metaphysical symbolism to universal allegory cannot be set forth in either logical or historical terms. The crystallising of symbol into allegory can be seen to happen in some literary traditions, but in the Middle Ages the two things were contemporaneous. Symbol was more philosophical and presupposed a certain originality

[12] Hugh of St. Victor, *In Hierarchiam Coelestem*, II (PL, 175, col. 949).

of outlook, as well as a less distinct and definite sense of the object. Allegory was more popular, more conventional and institutionalised. It was to be found in Bestiaries, in Lapidaries*, in the Hellenistic *Physiologos*†, in the *Speculum Ecclesiae* and *De Imagine Mundi* of Honorius of Autun, in William Durandus's *Rationale Divinorum Officiorum*.[13]

Interpreting the world allegorically meant interpreting it like the Bible, for the theory of Biblical exegesis was thought to be valid also for nature. Superimposed on the literal meaning of the Bible there was an allegorical meaning, a moral or tropological meaning, and an anagogical meaning. This doctrine underwent refinements right through the Middle Ages, from Bede to Dante. It is important to realise that there was an allegorical significance, as Bede and Hugh of St. Victor tell us, in things as well as in words. It had little to do with the elegant play of literary personification. It was a world rather in which everything was personification: 'all bodies have a likeness to good things which are invisible'.[14] Perhaps the best account of this condition is to be found in verses attributed to Alan of Lille:

Every creature of this earth
is like a picture or a book:
it is a mirror of ourselves.
It is a faithful mark
of our life and of our death,
of our state and of our fate.
The rose is a picture,
a fitting image of our state,
a lesson on our life;
for it flowers in early morning,
and the fading flower flowers
in the evening of age.[15]

* Books dealing with the medicinal and magical properties of precious stones.

† A collection of Christian allegories based upon the marvels and peculiarities of the animal world. It first appeared in Alexandria towards the end of the 2nd century, and was widely translated and read in the Middle Ages.

[13] Honorius of Autun, *Speculum Ecclesiae*, PL, 172, cols. 807–1107; *De Imagine Mundi*, PL, 172, cols. 115–87. William Durandus, *Rationale Divinorum Officiorum* (Treviso, 1479). Selections from Book I of Durandus are printed in Elizabeth G. Holt, I, pp. 120–9.

[14] Richard of St. Victor, *Benjamin Major*, II, 12 (PL, 196, col. 90).

[15] Quoted in ET, II, p.338.

The allegorical conception of nature was accompanied by an allegorical conception of art. Richard of St. Victor had a theory which dealt with both together. All of God's works, he said, were created as guidelines for men; but among the products of human industry some were allegorical and some were not. The literary arts lent themselves to allegory, while the figurative arts could feature a kind of derived allegory by representing literary personifications.[16] Outside the realm of theory, however, the allegorical content of the works of man gradually came to be felt more keenly than that of nature, and common opinion ended up very differently from Richard. The allegory of nature became weaker, more ambiguous and conventional; while art, even the figurative arts, came to be thought of as quite intentionally endowed with several meanings. The allegorical interpretation of the world lost ground, but poetic allegory remained familiar and deep-rooted. Progressive opinion in the thirteenth century firmly renounced the allegory of nature, but gave birth to the very prototype of allegorical poems, the *Roman de la rose*. And Classical poetry, too, was always read for allegorical meanings.[17]

This manner of artistic invention and understanding is looked upon with some hostility by the modern mind. It is thought to be a mark of aridity in poetry, of a deadening intellectualism. It is explained as the response to secular literature of a culture committed to a moralistic conception of life, and incapable of understanding art if it is not didactic. Now it is undeniable, of course, that art for the Medievals was above all didactic. As Aquinas wrote, 'It is the mark of the poetic arts to indicate the truth of things by means of invented similitudes'.[18] In an integrated culture such as that of the Middle Ages, nothing else would have been possible. But this does not really explain, fully, the allegorical bias of its art. Interpreting poetry allegorically did not mean imposing upon it some kind of arid and artificial system. It meant seeking in it what was felt to be the highest possible pleasure, the pleasure of a revelation *per speculum in aenigmate*. They responded

[16] *Benjamin Major*, II, 14 (PL, 196, col. 92).
[17] See Domenico Comparetti, *Vergil in the Middle Ages*, translated by E. F. M. Benecke (London and New York, 1895).
[18] *Quaestiones Quodlibetales*, VII, 6, 3.

not just to its lyricism but also to its symbolical values. It was always an object for the intellect.

Every age has its own poetic sensibility, and it would be wrong to use the modern sensibility as a basis for passing judgment upon the Medievals. Probably we are no longer capable of experiencing the subtle delight with which the Medievals uncovered in Virgil a world of prophecy and prefiguration. (Or, could it be that the reader of Joyce or Eliot feels something of the kind?) But if we do not at least acknowledge that they felt this delight, we are refusing to understand their mentality at all. The twelfth century illustrator of the Psalter of St. Alban of Hildesheim depicted the siege of a fortified city. If one is tempted to feel that the depiction lacks grace or correctness, one should remember that it is a spiritual, not just a material, representation. The siege is both physical and also a siege of those who are assailed by evil. The illustrator clearly believed that this type of interpretation was more complete and satisfying than a purely visual experience would be.

Attributing allegorical meanings to art meant regarding it in the same light as nature, as a living storehouse of images. Art was thought of in terms of intuition and feeling, in a culture for which intuition and feeling were fundamental attributes of mind, and therefore of the world. Art was seen as an organism, a *Gestalt*, in an age when nature also was thought of as something evolutionary, or at least as *Gestaltung*, as exhibiting an organic growth and development of forms. Nature was seen as a vast allegorical representation of the supernatural, and art was put on the same level.

Artistic allegory reached its apotheosis with the maturity of Gothic art, helped along by the encouragement of Suger. The cathedrals, the highest artistic achievement of medieval civilisation, became a surrogate for nature, a veritable *liber et pictura*, although organised in accordance with rules of interpretation which were in fact not wholly applicable to nature. There was significance in their architectonic structure, even in their geographical orientation. But even more in the figures above the portals, the designs on their windows, the monsters and gargoyles on the cornices, cathedrals actualised a synthetic vision of man, of his history, of his relation to the universe. Focillon writes, 'A considered arrangement of symmetries and repetitions, a law of numbers, a kind of music of symbols silently co-ordinate these vast

encyclopedias of stone'.[19] In arranging this figurative discourse, the Gothic masters used the mechanism of allegory. The legibility of the signs which they employed was guaranteed by a solid sociological fact, namely, the medieval habit of grasping certain analogies, of interpreting signs and emblems in the way that tradition had determined, of translating images into their spiritual equivalents.

The poetics of the cathedrals was ruled by an aesthetic principle, the principle of concordance. This derived primarily from the concordance of the Old and the New Testaments, for everything in the Old Testament was regarded as a prefiguration of the New. This 'typological' interpretation of Scripture led to the concordance of certain figures and attributes, of certain persons and episodes in the two Testaments. Thus the prophets were always recognisable by a particular kind of headgear which tradition attributed to them. And the Queen of Sheba always had a webbed foot. There was also a concordance between persons and the architectural environment. On the door of the Virgin in Chartres, the statue-pillars of the Patriarchs are situated on either side of the entrance. Samuel is recognisable because he holds the sacrificial lamb head downwards. Moses points with his right hand to a pillar in his left. Abraham's feet are on the ram and Isaac before him crosses his arms submissively. Placed in chronological order, these personages embody the expectations of a whole generation of precursors of the Messiah: Melchisedech, the first priest, leads the company with chalice in hand; and St. Peter, on the threshold of the New Dispensation, brings up the rear in the same stance, a sign of the revealed mysteries. The group appears above the doorway as if in the vestibule of the New Covenant whose mysteries are celebrated within. The history of the world, as expressed in the Scriptural concordance, takes the form of a sequence of images. The mathematics of the allegory are perfect: the architectural, the plastic, and the semantic come together to teach and communicate.[20]

[19] Henri Focillon, *The Art of the West*, translated by Donald King, 2 vols. (London, 1963), I, p. 8.
[20] This example is taken from Emile Mâle, 'Le Portail de Senlis', in *Art et artistes du moyen age* (Paris, 1947).

4. The most rigorous theory of allegory was that of St. Thomas Aquinas. Rigorous and also novel, because it marked the end of cosmic allegory and led to a more rational view of phenomena. Aquinas asked these questions: do the Scriptures gain any advantage from their use of metaphors? And, do the Scriptures yield more than one meaning? He answered the first question in the affirmative; it is indeed advantageous 'to transmit the things of God and the spirit by means of corporeal similitudes'.[21] If spiritual realities can be grasped by way of sense knowledge, they are more accessible to the human consciousness.

In answer to the second question, Aquinas said that the first level of meaning in the Bible is historical or literal, and that this is the foundation of its spiritual meaning, which comprises the other three kinds: allegorical, moral, and anagogical. But the spiritual meaning emerges not so much from the literal meaning itself as from the events to which the literal meaning refers. This view, that the events narrated in the Bible foretell events in the future, was in fact quite a traditional one; 'God disposed the course of affairs so as to signify certain things'.[22] But Aquinas broke with tradition in holding that natural objects have an allegorical significance only in the context of Scripture. He reduced cosmic allegory to Biblical allegory. Natural objects in themselves had no allegorical meaning; at least, Aquinas nowhere said that they do. And the arts also, had only a literal meaning. To be precise, they had a kind of meaning which Aquinas called 'parabolic', a meaning which 'does not go beyond the literal sense'.[23] By this he meant that a poetic image and its customary meaning – what is normally called its allegorical meaning – are connected up only in the mind of the reader or listener. They are grasped in a single mental act, with no special hermeneutic effort. This is because the association of an image with a certain meaning is a matter of habit, as when a lamb is conventionally used to represent Christ. Parabolic meaning, therefore, was rooted in sensibilities educated in a tradition of allegory. It was conventional meaning, not the kind generated in mysticism or in metaphysics. 'Words can signify something properly

[21] S.T., I, 1, 9.

[22] *Quaestiones Quodlibetales*, VII, 6, 3.

[23] *Quaestiones Quodlibetales*, VII, 6, 3.

and something figuratively; the literal sense is not the figure of speech itself, but the object which is figured.'[24]

With this argument, nature lost its semantic and surrealistic qualities. It was no longer a 'forest of symbols'. The cosmos of the early Middle Ages gave way to a universe which we could call scientific. Earlier, things had possessed a value not because of what they were but because of what they meant; but at a certain point it was realised that God's creative activity was not an organising of signs but a reifying of forms. Even Gothic figurative art, which was the highest point of the allegorical sensibility, reflected the new climate. For alongside its vast symbolical ideations there were some pleasant little figures which reveal a freshness of feeling for nature and a close attentiveness to objects. Hitherto, no one had really *observed* a bunch of grapes, because grapes had first and foremost a mystical significance. But now one could see stems and shoots, leaves and flowers, decorating the capitals. The doorways blossomed with precise depictions of everyday gestures, of crafts, of farmwork. The allegorical figures were also realistic, full of life of their own, even if they were closer to a type or ideal of man than to his psychological individuality.

The twelfth century was interested in nature. The following century, which had accepted Aristotle, focussed on the concrete form of things. All that survived of the universal allegory were the dizzying mathematics that gave such power to the *homo quadratus*. So in the fifteenth century we find Alan de la Roche multiplying the ten commandments by the fifteen virtues, in order to obtain one hundred and fifty moral habits. Yet for three centuries sculptors and painters had been taking to the woods in Spring to observe the life and rhythm of nature. And Roger Bacon pronounced that goat's blood was not essential for fracturing diamonds. The proof: 'I saw it with my own eyes'.

A new kind of aesthetic awareness was born, an aesthetics of the concrete organism. It arose not because of deliberation, but rather out of the complexities of a new philosophy of concretely existing substances.

[24] S.T., I, 1, 10 ad 3.

VI. Aesthetic Perception

1. In the thirteenth century, thinkers began to take a keen interest in the concrete reality of things, and this was accompanied by intensive scientific and philosophical study of the psychology of vision. In the case of aesthetic perception there was a dual aspect to the problem. On the one hand, whatever was objectively beautiful should be perceived as beautiful. On the other hand, works of art were designed with aesthetic perception in mind; they presupposed the nature of perceptual experience in the subjectivity of the recipients.

Even in ancient times, Plato had been aware of this twofold aspect. In *The Sophist* he wrote:

> If [painters and sculptors] reproduced the true proportions of beautiful forms, the upper parts, you know, would seem smaller and the lower parts larger than they ought, because we see the former from a distance, the latter from near at hand. . . . [Artists] . . . give their figures not the actual proportions but those which seem to be beautiful.[1]

Tradition associated this problem with Phidias. The lower part of his *Athene* seemed too short when seen close up, but assumed the correct dimensions when placed above the level of the eye and looked at from below. Vitruvius, too, distinguished between symmetry and 'eurhythmy' (*euritmia*); the latter was the type of beauty that depends upon the requirements of vision. It was primarily a set of technical rules connected with the way in which the eye sees things,

[1] Plato, *The Sophist*, 235 and 236a, translated by H. N. Fowler (London and Cambridge, 1921).

rather than with the purely objective proportions of objects. It was not just in the Renaissance that people became aware of this, although it is true that the theory of perspective was developed in the Quattro-cento. Nor is it altogether accurate to say that the Medievals believed 'the subject as well as the object to be submerged in a higher unity'.[2] The statues in the King's Gallery in Amiens Cathedral were designed to be seen from a floor thirty metres below; the eyes were placed far from the nose, and the hair sculpted in great masses. At Rheims, statues on the spires have arms that are too short, backs that are too long, lowered shoulders, and short legs. The demands of objective proportion were subordinated to the demands of the eye. In practice, then, artists were aware of the subjective element in aesthetic experi-ence, and made allowance for it.

2. Philosophy dealt with this issue in a much more abstract man-ner, to the point almost of losing any connection with what interests us here. However, in the end the question is how the subject and object are related, and it is this question which preoccupied the phil-osophical theories that we are going to look at. We have already seen that Boethius made some indirect reference to aesthetic proportions which were designed to satisfy the psychological needs of the obser-ver. Earlier still, St. Augustine had often discussed the relations between objects and the mind, for instance in his analysis of rhythm. And in his *De Ordine*, Augustine attributed an aesthetic character only to visual perception and moral judgment; hearing, and the lower senses, had to do with *suavitas* rather than *pulchritudo*. This in turn gave rise to the theory that certain senses were especially well adapted for knowledge (*maxime cognoscitivi*), a theory taken up in Aquinas's system, where the senses in question are those of sight and hearing. In the psychology of the Victorines, the joy felt in experienc-ing sensuous harmony was a prolongation of physical pleasure; it was rooted in the affective life, and grounded in an ontologically real cor-respondence between the structure of mind and the structure of mat-ter.[3] Richard of St. Victor, for whom contemplation could at times

[2] Erwin Panofsky (1970), p. 130.
[3] This is not altogether unlike the modern *Einfühling* theory.

have an aesthetic character, defined it as 'a state of clear insight and admiration at the spectacle of wisdom'.[4] In such moments of ecstasy the soul expands, uplifted by beauty, wholly absorbed in the object.

St. Bonaventure, somewhat more solemnly, said that sense knowledge is governed by a rule of proportion: 'We say there is *suavitas* when an active power does not overwhelm its recipient too disproportionately: for the senses suffer from excess but delight in moderation.'[5] And pleasure arises when the object is a pleasurable one: 'For delectation results from a conjunction of the delectable and a person who takes delight in it.'[6] There is an element of love in this relation. For the highest pleasure comes not from sense knowledge but from love, and involves an awareness of proportion and reciprocity in the object. In love, subject and object both lend themselves consciously and actively to the relationship: 'This affection of love is noblest of all because it partakes in liberality to the highest degree ... As far as creatures are concerned, nothing is so delightful as mutual love, and without love there is no delight.'[7]

In Bonaventure, this affective theory of contemplation is expressed rather cursorily, for it is merely a corollary of his epistemology of mysticism. William of Auvergne dealt with it more fully; it is the basis of his so-called emotionalism. He stressed the subjective aspect of contemplation, and the role of pleasure in the experience of beauty: 'For we call a thing visually beautiful when of its own accord it gives pleasure to spectators and delight to the vision.'[8] There is an objective quality in the beautiful object which leads to a consensus of judgment, but the arbiter and sign of its beauty is the pleasurable approbation which accompanies the visual sensations: 'If we wish to understand visual beauty we must consider the sense of sight ... Beauty and ornament which our looking and seeing approve of [*approbat*] and take pleasure in ... '[9] On this issue William always employed two kinds of terms: terms pertaining to cognition (*spectare, intueri, aspicere*), and those pertaining to the affections (*placere,*

[4] *Benjamin Major*, I, 4 (PL, 196, col. 67).

[5] *Itinerarium Mentis in Deum*, II, 5.

[6] *In I Sent.*, 1, 3, 2.

[7] *In I Sent.*, 10, 1, 2.

[8] William of Auvergne, *De Bono et Malo*. Quoted in LB.

[9] ibid.

delectare). His theory of the soul was that its two functions, the cognitive and the affective, were indivisibly entwined. If an object were simply present to some consciousness, and manifested its properties, it would provoke a sense of delight and attraction. The subject simultaneously knows beauty and reaches towards it.[10]

3. The very general character of these philosophical theories contrasts sharply with research that was going on at the same time into the psychological mechanisms of visual perception. These researches are exemplified in the works of Alhazen and his followers. The *Liber de Intelligentiis* explained the phenomenon of sight on the model of reflected light. A luminous object produces its image in a mirror by emitting light rays. It is an active force, productive of reflected images, and the mirror is simply a passive potency suitable for receiving it. The human mind is particularly well adapted for receiving this active force, and when it does so consciously it experiences pleasure. The highest pleasure is when a luminous object encounters the luminous nature within us. This pleasure is based upon the proportions among things, in particular the adaptation of mind and world to one another. It is based ultimately on the metaphysical love which binds reality together.[11]

Witelo, in *De Perspectiva*, analysed the subject-object relation more fully, and arrived at an interesting theory of the internal processes involved in cognition.[12] He distinguished two kinds of visual perception. One was 'a grasp of visible forms . . . through intuition alone'; the other was perception 'though intuition together with preceding knowledge'. The first type is exemplified in the perception of light and colour. More complex realities require 'not just sight alone, but also other acts of the soul'. As well as the pure intuition of visible properties there is 'an act of reason which compares the different forms perceived with one another'. Only after this 'dialogue' with the object of perception do we acquire a knowledge of it which

[10] William of Auvergne's theory of the soul is discussed in ET, III, pp. 80–2.

[11] For the text of *Liber de Intelligentiis*, see Clemens Baumker, *Witelo* (Münster, 1908), pp. 1–71. See in particular chaps. XII and XVIII.

[12] Parts of Witelo's *De Perspectiva* are printed in Clemens Baumker, *Witelo*, pp. 127–79. For the argument summarised here, and the passages quoted, see p. 143 and pp. 172–5.

is also conceptual. Visual sensations are complemented by memory, imagination, and reason, and the synthesis of all of these is swift, almost instantaneous. Aesthetic perception is of this second type. It involves a swift but complex interaction between the multiplicity of objective properties available to perception and the activity of the subject in comparing and relating them: 'Forms are beautiful not because of particular intentions or a number of related intentions . . . The beauty of visible things arises from the mutual conjunction of a number of intentions and visible forms, not from (particular) intentions alone.'

Witelo next seeks to determine the objective conditions, the features of visible forms which make them pleasing. There are simple properties such as magnitude; this is why the moon is more beautiful than the stars. There is the pattern or design (*figura*) of a form. There is continuity, as in great expanses of greenery; and discontinuity, as in the multitudinous stars, or lighted tapers. There is the roughness or the smoothness of bodies seen in the light, and also the shading which alleviates the harshness of light and creates soft masses of colour, as in a peacock's tail. Then there are complex properties, for instance when pleasing colours combine with pleasing proportions; different properties interact to produce a new and more sensuous beauty.

Witelo formulated two further principles which are of great interest. The first was that there is a certain relativity in taste, so that it varies in different times and places. Visual properties possess a quality of suitability (*convenientia*) which is not the same everywhere. 'Each person', Witelo writes, 'makes his own estimate of beauty according to his own custom'. The second principle was that the subjective side of sense experience is an accurate measure of how to evaluate and enjoy the object aesthetically. Some things should be viewed from a distance, if there were unsightly marks on them for example. Others, miniatures for instance, should be looked at close up if we want to see all of the detail, all of the hidden intentions (*intentiones subtiles*), the decorum of line (*lineatio decens*), and the beautiful ordering of parts (*ordinatio partium venusta*). Distance and nearness, then, are essential factors in aesthetic experience. So also is the axis of vision, since an object may change its appearance if looked at obliquely.

4. It is scarcely necessary to stress the importance of Witelo, and the maturity of his aesthetics, nor the extent to which he assists us in understanding St. Thomas Aquinas. Aquinas's aesthetics was not as analytic and complete as Witelo's, but it inhabited the same climate. Witelo's book appeared in 1270, the *Summa Theologiae* was begun in 1266 and completed in 1273: the two works belonged to the same period, dealt with similar problems, and stood at the same point of development.

The aesthetic theories of Albertus Magnus encouraged Aquinas to take an interest in the subjective aspect of aesthetic experience. Albertus, it may be recalled, described beauty as the resplendence of substantial form, in an object whose parts are well-proportioned. 'Resplendence' referred to an entirely objective quality, an ontological splendour, which existed whether or not it was an object of knowledge. And it was a quality found in that principle of organisation which transforms multiplicity into unity. Aquinas accepted, implicitly at any rate, the view that beauty was a transcendental,[13] but his definition of beauty surpassed that of Albertus. In a passage in the *Summa*, where he has just been asserting the identity and difference of the good and the beautiful, he continues as follows:

> For good (being what all things desire) has to do properly with desire and so involves the idea of end (since desire is a kind of movement towards something). Beauty, on the other hand, has to do with knowledge, and we call a thing beautiful when it pleases the eye of the beholder. This is why beauty is a matter of right proportion, for the senses delight in rightly proportioned things as similar to themselves, the sense-faculty being a sort of proportion itself like all other knowing faculties. Now since knowing proceeds by imaging, and images have to do with form, beauty properly involves the notion of form.[14]

This is an important passage, which clarifies a number of fundamental points. The beauty and the goodness of a thing are the same, because they are both grounded in form; this was in fact a fairly

[13] This issue is discussed in Umberto Eco, *Il Problema Estetico in Tommaso d'Aquino*, 2nd edition (Milan, 1970), chap. 2.

[14] S.T., I, 5, 4 ad 1.

common view. But a form possesses goodness in so far as it is the object of an appetite, that is, the object of a desire for the realisation or the possession of the form, in so far as the form is positive. Whereas beauty subsists in the relation of a form to knowledge alone. Things are beautiful which please when they are seen (*visa placent*).

The word *visa* means, in fact, not just 'seen' but 'perceived' in the sense of being known. For Aquinas *visio* meant *apprehensio*, a cognition; so that the beautiful was *id cujus apprehensio placet*[15] – something the apprehension of which is pleasing. *Visio* is knowledge. It has to do with formal causes. It is not just that the sensuous properties of the things are seen; rather, there is a perception of properties and qualities which are organised according to the immanent structure of a substantial form. It is an intellectual, conceptual act of comprehension. This interpretation of the Thomistic term *visio*, as a type of knowledge, is justified by several passages in the *Summa*.[16] Beauty is actualised in the relation of an object to the mind which knows it and its beauty; and it is the objective properties of things which guarantee the validity and pleasure of the experience: 'There are three requirements for beauty. Firstly, integrity or perfection – for if something is impaired it is ugly. Then there is due proportion or consonance. And also clarity: whence things that are brightly coloured are called beautiful.'[17] These three well-known properties, taken from a long tradition, are what beauty *consists in*. But the rationality of beauty has to do with cognition, with *visio*. And pleasure is another factor which is essential to beauty.

It is clear that, in the Thomistic view, pleasure is caused by a potentiality in things which is fully objective. It is not the case that pleasure defines or determines beauty. The problem here is a very real one, which had already cropped up in St. Augustine. He had asked whether things are beautiful because they give delight, or give delight because they are beautiful; and it was the latter view which he adopted.[18] But any theory which gives primacy to the will tends to regard the pleasure as a feeling deliberately and freely attached to

[15] S.T., I–II, 27, 1 ad 3.
[16] S.T., I, 67, 1; S.T., I–II, 77, 5 ad 3.
[17] S.T., I, 39, 8.
[18] St. Augustine, *De Vera Religione*, 32.

the object, not determined by it. We find this view in Duns Scotus. Scotus held the theory that 'the will controls its act just as the intellect controls its act'.[19] Aesthetic perception, then, 'is a free potency for participating, so long as its act is subordinate to the rule of the will; and this for the more and the less beautiful alike'.[20] By contrast, in a theory that gives primacy to the intellect, as is the case with Aquinas, it is clearly the objective properties of a beautiful thing which determine the aesthetic experience of it. Still, these properties are actualised in *visio*, they are properties that are known to someone. And this alters somewhat the view that we take of the objectivity of beauty.

The term *visio* signifies a disinterested knowledge. It has nothing to do with the ecstasies of mystical love, nor with sensuous responses to sense stimuli. It has nothing to do either with the empathetic relation to objects which is the mark of Victorine psychology. It signifies an intellectual type of cognition, which produces a disinterested type of pleasure: 'It pertains to the notion of the beautiful that in seeing or knowing it the appetite comes to rest.'[21] Aesthetic experience does not mean possessing its object, but contemplating it, observing its proportions, its integrity, its clarity. So that the senses which are concerned most with perceiving beauty are those which are *maxime cognoscitivi*. 'We speak of beautiful sights and of beautiful sounds.'[22]

It is also wrong to think of *visio* as intuition in the modern sense of the term – not even, as some would have it, an 'intellectual intuition'. Neither intuition nor intellectual intuition is part of the Thomistic epistemology. Maritain looks upon intuition as a kind of apprehension in and through the sensible which is prior to abstraction.[23] But this has no place in an epistemology for which the first cognitive act is abstraction, a *simplex apprehensio*: an act which stamps an intelligible species on the possible intellect as the basis for concept-formation.[24] For Aquinas, the intellect cannot know

[19] John Duns Scotus, *Opus Oxoniense* (*Quaest. in Lib. Sent.*), IV, 49, 4, 4.

[20] *Opus Oxoniense*, I, 1, 5, 1.

[21] S.T., I–II, 27, 1 ad 3.

[22] S.T., I–II, 27, 1, ad 3.

[23] J. Maritain, *Art and Scholasticism*. See for example pp. 44–9.

[24] S.T., I, 84 and I, 85, 1–2–3. In this connection, see M. D. Roland-Gosselin, 'Peut-on parler d'intuition intellectuelle dans la philosophie Thomiste?', in *Philosophia Perennis* (Regensburg, 1930).

sensible particulars, and it is only after the abstraction, in the *reflexio ad phantasmata*, that it comes to know sense objects.[25] The human intellect is discursive. So also is the aesthetic *visio*; it is a composite act, a complex apprehension of the object. Sensible intuition may put us in touch with some feature of a particular object, but the complex of concomitant conditions which determine the object, its position in space and time, its very existence, are not intuited. They demand rather the discursive process of the act of judgment. For Aquinas, aesthetic knowledge has the same kind of complexity as intellectual knowledge, because it has the same object, namely, the substantial reality of something informed by an entelechy.

[25] S.T., I, 86, 1.

VII. The Aesthetics of the Organism

1. THE expression 'aesthetics of the organism' fits Aquinas better than 'aesthetics of form', for the following reason. When Albertus Magnus referred to beauty as a resplendence of substantial form he was clearly thinking of form as an entelechy, which actualises the potentialities of matter, uniting with matter to compose a substance. Beauty was the irradiation of this organising principle in the matter which it unifies. In Aquinas, however, if we interpret the concepts of clarity, integrity and proportion in the light of his whole philosophical system, we must conclude that 'form' in his theory of beauty has to do with a whole substance rather than with substantial form. What he had in mind was a concrete synthesis of matter and form, therefore a whole organism.

The use of the term 'form' to mean 'substance' is fairly common in Aquinas. 'Form' is sometimes used in the superficial sense of *morphē*, or shape – that is, a quality of the fourth species, the quantitative boundary of a body, its tridimensional contour.[1] Or it can mean the substantial form which achieves existence only when incorporated in matter, escaping thus from its essential abstractness. Or finally, it can signify an *essentia* – that is, a substance in so far as it is something comprehended and defined.

It was characteristic of Aquinas's metaphysics that he should consider objects in their substantial concreteness. The orthodox Aristotelian position was to concentrate upon substantial form, and this orthodoxy had affinities also with Platonism. Platonism likes to isolate the idea in the sensible (or the idea as opposed to the sensible);

[1] S.T., I–II, 110, 3 ob. 3.

it interprets the dialectic of idea and reality as a dialectic of things and their essences. The *id quod est* or *ens* is distinguished from the *quo est*, the conceptual essence. It is of course a much more critical pespective than the one adopted by those who explain the world symbolically, for whom the mystical significance of a thing is more real than the thing itself. However, in an ontology of essences there is always a tendency, however subterranean, to succumb to idealism, to the feeling that it is more important for a thing to be definable than to simply 'be there'.

Now the novelty of Aquinas's ontology lies precisely here: he proposed an *existential* ontology, in which the primary value was *ipsum esse*, the concrete act of existence. He superimposed the constitutive and determining combination of essence and existence upon that of matter and form. For Aquinas, the *quo est* did not explain the *ens*; form without matter was nothing. But when, through divine participation, form and matter united in an act of existence, a relation was established between the organising principle and what was organised. At this point what counted was the whole subsistent organism, the substance whose proper act was *ipsum esse*.[2] Being was no longer a mere accidental determination of essence, as it had been for Avicenna, but something which made the essence possible and actual, and also the substance of which it was the essence. The connection between form and substance was so profound, neither subsisting without the other, that for Aquinas the very term 'form' implied 'substance' – excepting, of course, the specific case where form and substance were being logically distinguished. Thus the concept of essence or *quidditas*, of form conceived of as something formative, was redolent above all of the act of existing. In this ontology, the hyperuranic worlds were overtaken by life, and it is scarcely necessary to stress the radical import of this new Thomistic conception of things for the medieval mentality.[3] Arnold Hauser has rightly drawn attention to its connection with the development of culture and of social relations:

> Organic life, which after the end of the ancient world had lost all meaning and value, once more comes to be honoured, and the

[2] *Summa Contra Gentiles*, II, 54.
[3] See Etienne Gilson, *The Christian Philosophy of St. Thomas Aquinas* (London, 1957), Part I, chap. 1.

individual things of experienced reality are henceforth made sub-
jects of art without requiring some supernatural, other-worldly
justification . . . The God who is present and working in all the
orderings of nature corresponds to the attitude of a more liberal
world in which the possibility of rising is not entirely excluded.
The metaphysical hierarchy of things still reflects a society that is
built up of estates, but the liberalism of the age already voices itself
in the conception that even the lowest stage of being is in its own
way indispensable.[4]

We must not, of course, desacralise the essentially theocentric uni-
verse of Aquinas; his ontology of concrete existence should always be
interpreted in the light of the metaphysics of divine participation.
But at the same time we must recognise the growth of naturalism
and humanism in his philosophy.

2. In the light of all this, we can turn now to the three criteria of
beauty in Aquinas: integrity, proportion, and clarity. It seems reas-
onable to argue that they acquire their full meaning only when
thought of as characteristics of a concrete substance, rather than of
substantial form. And indeed, there are several illustrations of this
view in the various meanings of the term 'proportion'.
 One type of proportion is the appropriateness of matter to form,
the adequacy of a potentiality to its organising principle. In the
Summa Contra Gentiles Aquinas writes, 'Thus, form and matter must
always be mutually proportioned and, as it were, naturally adapted;
for the proper act is produced in its proper matter'.[5] And in his Com-
mentary on the *De Anima* he emphasises that proportion is not a
mere attribute of substantial form, but is the very relation itself
between matter and form – to such a degree, in fact, that if matter is
not disposed to receive the form, the form disappears.[6] This sense of
the term is of special interest in aesthetic experience, the object of
which is a structural grace in things.
 Proportion can refer to another kind of relation, more metaphysical

[4] Arnold Hauser, *The Social History of Art*, 2 vols. (London, 1951), I, p. 233.
[5] *Summa Contra Gentiles*, II, 81.
[6] *Comm. de Anima*, I, 9, 144.

in character and beyond the reach of aesthetic experience. This is the relation of essence to existence, a proportion which, although it cannot be experienced aesthetically, makes aesthetic experience possible by giving concreteness to things. The other types of proportion are phenomenal consequences of this metaphysical proportion, and it is they which answer most directly to our aesthetic requirements. Aquinas mentions the ordinary sensuous and quantitative type of proportion, the proportion found in a sculpture or a melody. 'Man', he says, 'experiences pleasure in sensations . . . because they are pleasing in themselves . . . Thus he enjoys music . . . '[7] He also talks of proportion in the sense of a purely intelligible decorum in moral behaviour and in rational discourse, referring here to the intelligible beauty so admired by the Medievals: 'spiritual beauty consists in conversation and actions that are well-proportioned in accordance with the spiritual light of reason'.[8] This view is less perverse than it might sometimes seem to the modern mind. There is something of a return nowadays to the idea that there is an aesthetic quality in rational and practical activities, and in mathematical and logical reasoning.

Aquinas refers also to a psychological type of proportion, the suitability of a thing for being experienced by a subject. This conception, which derived from Augustine and Boethius, has to do with the relation between the knower and the known. When we reflect upon the objective and rule-governed character of perceived phenomena, we discover our own connaturality with their proportions, that there are proportions also in ourselves.[9]

Thus proportion is conceived of as something objective, something realised on an infinite number of levels, and something which finally coincides with the cosmic proportions of an ordered universe. In his discussion of visual proportion Aquinas reverts to the type of cosmological theory which we looked at earlier; but his descriptions of the cosmic order possess a certain personal vigour and originality of tone.[10]

There is one further type of proportion which is of central

[7] S.T., II–II, 141, 4 ad 3.
[8] S.T., II–II, 145, 2.
[9] See S.T., I, 5, 4 ad 1, and *Comm. de Anima*, III, 2, 597–8.
[10] See *Comm. Div. Nom.*, IV, IX, X, XI.

importance in Aquinas's aesthetics, and is a constant in medieval aesthetics. This is proportion in the sense of the adequacy of a thing to itself and to its function. The Scholastics referred to it as the 'first perfection' (*perfectio prima*), the adequacy of a thing both to its species and to its own individual nature. 'For it is evident', Aquinas writes, 'that everything in nature has a certain end, and a fixed rule of size and growth . . . '[11] Thus, people may differ from one another in size and shape, but if the variations go beyond certain limits there is no longer a true and proper human nature, but abnormality instead. This kind of perfection is related to another criterion of beauty, integrity. *Integritas* means the presence in an organic whole of all the parts which concur in defining it as that which it is. The human body, for instance, is deformed if a limb is missing: 'we call mutilated people ugly, for they lack the required proportion of parts to the whole'.[12] Clearly these are principles of an aesthetics of the organism in every sense, and they are not without interest nowadays in a phenomenology of artistic form. However, Aquinas's concept of first perfection is rather limited when he refers it to art: a work of art, he says, is complete if it is adequate to the idea in the mind of its maker.[13]

When the first perfection is present in a thing, it is then adequate to its proper end. It also acquires the 'second perfection' (*perfectio secunda*), which means that it operates in accordance with its proper finality. Furthermore, the second perfection regulates the first perfection, because if a thing is to be truly complete its structure should accord with its function: 'the end is operative before anything else . . . for an effective action is complete only through its end'.[14] The efficient cause constructs a thing in accordance with its end. For this reason, a work of art (of *ars* that is – human making in general) is beautiful if it is functional, if its form is adequate to its scope. 'Every craftsman aims to produce the best work that he can, not in a simple manner, but by reference to the end.'[15] If an artist made a saw out of glass it would be ugly despite the beauty of its appearance, because it could not fulfil its cutting function. The human body is beautiful because it is constructed

[11] *Comm. de Anima*, II, 8, 332.
[12] *In IV Sent.*, 44, 3, 1.
[13] S.T., I, 16, 1.
[14] *De Principiis Naturae*, 11.
[15] S.T., I, 91, 3.

with an appropriate distribution of parts: 'I claim therefore that God disposes the human body in the best possible fashion as being appropriate to its form and operations'.[16] The human organism sustains a complex arrangement of relations between the forces of mind and body, the higher and the lower powers, so that all its features are there for precise reasons. There are functional reasons why the human senses, with the exception of the sense of touch, are less developed than those of other animals: for example, his sense of smell is weak because smell thrives in conditions of dryness, and the large size of the human brain creates humidity – a humidity necessary to cope with the heat given off by the heart. Man has no feathers, horns or claws because these are things that show a preponderance of the terrestrial in animals, while in man the terrestrial is balanced by other elements. By way of compensation man has hands, the *organum organorum*, which make up for every other deficiency. Finally, man is beautiful because of his erect posture. He is made this way because if his head were in an inclined position it would interfere with the sensitive internal forces centred in the brain; also because his hands need not be used for locomotion and so are freed for their own business; finally, because if men had to grasp food with their mouths their linguistic capacities would be impaired. For all these reasons man is erect, and is thus enabled to use his most noble sense, the sense of sight, 'to freely acquire knowledge of every kind of sensible object, both in the skies and on the earth'.[17] He can cast his eye at will over the earth and its beauty. Only man can enjoy the beauty of sensible objects for its own sake (*solus homo delectatur in pulchritudine sensibilium secundum seipsam*).[18] In this account of the human body, it is clear that its aesthetic value and its functional value are one and the same. The scientific principles of the age were also its principles of beauty.

Aquinas's functionalist theory of beauty gave systematic expression to a sentiment which was very characteristic of the Middle Ages as a whole. This was its tendency to identify the beautiful and the useful, an identification which itself originated in the equation of the beautiful and the good. The identity of beauty and use seemed to be required in

[16] S.T., I, 91, 3.
[17] S.T., I, 91, 3 ad 3.
[18] ibid.

many of their life experiences, even when they were trying to distinguish theoretically between them. Here again we must refer to their integrated sensibility. In fact the difficulty which they had in distinguishing beauty and function shows how there was an aesthetic element in every department of life. They could no more subordinate beauty to goodness or use than they could subordinate goodness and use to beauty.

Whenever contemporary man finds that art and morality are in conflict, this occurs because he is trying to reconcile a modern conception of the aesthetic with a classical conception of the moral. The present-day problem of integration (without entering here into the merits of the question) takes the form of a revision of traditional ideas to see which of them still have a value in our historical situation, and which of them have lost their significance for us. For the Medievals, a thing was ugly if it did not relate to a hierarchy of ends centred on man and his supernatural destiny; and this in turn was because of a structural imperfection which rendered it inadequate for its function. It was a type of integrated sensibility which made it hard for the Medievals to experience aesthetic pleasure in anything which fell short of their ethical ideals; and conversely, whatever gave aesthetic pleasure was also morally justified, in cases where this was relevant.

In practice, they did not express this sensibility in a perfect and balanced manner. On the one hand there was someone like St. Bernard, who liked gargoyles but rejected them because of his excessive strictness. On the other hand there were the goliardic songs; or there was Aucassin preferring to follow Nicolette to the underworld rather than live in a paradise for ancient dotards. However, neither was any more 'medieval' than the other. They were departures from the ideal, but the philosophy of first and second perfections represented a kind of optimum cultivated by the Medievals within varying schemes of values. The Thomistic theory was too pure to find its unequivocal counterpart in concrete acts of taste and judgment, but it did express, on a deontological level, the fundamental co-ordinates of a civilisation and its conventions.

Confident in the soundness of his philosophy, Aquinas could even grant a certain autonomy to art: 'for a craftsman, as such, is commendable not because of his intentions, but because of the work he

produces'.[19] The moral intention is discounted here. What matters is that the object should be well made, and it is well made if it is positive in all its aspects. An artist might construct a building with perverse intentions, but there is no reason why it should not be aesthetically perfect and good so long as it fulfills its function. A sculptor might, with the best intention in the world, create an immodest work liable to disturb someone's moral balance. In such a case, the Prince should banish the work from the City; for the City is founded on an organic integration of ends and cannot tolerate any disturbance of its *integritas*.[20] The rhythm of morality is ruled by an aesthetic principle.

3. All of this, as we have seen, is grounded on the principle that the bearer of aesthetic value is the concrete organism in all the complexity of its relations. As a consequence, the concept of clarity, or splendour, or light, has quite a different meaning in Aquinas from what it meant for the neo-Platonists for instance. In neo-Platonism, light descended from above and diffused itself creatively in the world; it gathered and solidified in things. But Aquinas held that clarity rises from below, from the heart of things. It is the organising form manifesting itself. Physical light is 'a consequence of the substantial form of the sun';[21] the clarity of glorified bodies is the luminosity of the soul in its blessedness, overflowing throughout the physical body; and the clarity of Christ's transfigured body 'overflows from His soul'.[22] Thus, the colour and luminosity of bodies are produced by bodies when they are correctly structured according to their natural needs.

But on the ontological level, *claritas* refers to the expressive capacity of organisms. It is, as someone put it, the radioactivity of the form of things. *Claritas* is the one principle of expressiveness in medieval times which could fill the place occupied nowadays by such concepts as the lyricism or symbolism or the iconicity of form. An organism which is fully perceived and grasped reveals its organic

nature, and the intellect can enjoy the beauty of its discipline and order. This ontological expressiveness is not something that exists even when it is not an object of knowledge; rather, it becomes real and manifest when the *visio* focuses upon it, a form of disinterested observation which regards the object under the aspect of its formal cause. The object is ontologically predisposed to be judged as beautiful. But the judgment is not made until the observer, conscious of the proportion between himself and the object, and aware of all the properties of the completed organism, enjoys the resplendence of this completeness fully and freely for himself. Ontologically, *claritas* is clarity 'in itself', and it becomes aesthetic clarity or clarity 'for us' in a specific perception of it.

It follows that the aesthetic *visio* is for Aquinas *an act of judgment*. It entails activities of collocating and distinguishing, the mensuration of parts with respect to the whole, studies of how the matter lends itself to the form, an awareness of purposes and of how adequately they are fulfilled.[23] Aesthetic perception is not an instantaneous intuition, but a 'dialogue' with its object. The dynamism of the act of judgment corresponds to the dynamism of the act of organised existence which is the object of judgment. In this connection Aquinas writes, 'To say that the appetite desires the good, and peace, and the beautiful, is not to say that it desires different things'.[24] By peace he means the tranquillity of order (*tranquillitas ordinis*). After the travail of the act of discursive understanding, the intellect rejoices at the vision of an order and integrity which are manifest in their own clear presence. More than just pleasure, there is peace, peace which 'causes the removal of disorder and of obstacles to the good'.[25] The pleasure experienced in perception is a free pleasure, the pleasure of contemplation free from desire and content with the perfection which it admires. Beauty is what pleases when it is seen, not because it is intuited without effort, but because it is through effort that it is won, and when the effort is successful it is enjoyed. We take pleasure in knowledge which has overcome the obstacles in its path and so brought about the quiescence of desire.

[23] See S.T., I, 85, 5.
[24] *De Veritate*, 22, 1 ad 12.
[25] ibid.

This part of the Thomistic philosophy represents the highest point in medieval intellectualism. It is clear that nothing could be further from certain modern theories of aesthetic intuition. But it is still of value nowadays, for its basic conception of aesthetic experience is of something active, discriminating, and critical.

VIII. Development and Decline of the Aesthetics of the Organism

1. AQUINAS demonstrated that it was possible to devise a metaphysics of beauty which was not Platonist. His aesthetics moved closer to a kind of humanism. There were other thirteenth-century examples of hylomorphic aesthetics, but none achieved the naturalistic vigour of Aquinas.

Sometime between 1248 and 1252, Albertus Magnus gave a university course in Cologne which consisted of a commentary on the fourth chapter of the *De Divinis Nominibus*. Aquinas was one of his students, and so also was Ulrich of Strasbourg. Ulrich's *Summa de Summo Bono* was written at about the same time as Aquinas's *Summa*. It contained an aesthetic theory based upon the concepts of form, light and proportion. Indeed, his analysis of proportion was much more precise and specific than Aquinas's (which has to be pieced together), and was more openly connected with aesthetic issues. But his concept of form was heavily neo-Platonic, deficient in the concrete qualities of the Thomistic 'substance'. For Ulrich, beauty was *splendor formae* in Albertus Magnus's sense; but the 'form' in question was more akin to the neo-Platonic 'light', and his conception of the visible world revealed the influence of the *Liber de Causis*.[1] 'Every form is an effect of the intelligence of the First Light, which is operating in the depths of its nature. Thus it follows necessarily that a form participates in the light of its causes, by virtue of similarity.'[2] Beauty was the flooding of matter with form under the influence of the Divine Light. Yet matter was in the end an impediment to form,

[1] A work long attributed to Aristotle, but now identified as the *Institutio Theologica* of Proclus.
[2] Ulrich of Strasbourg, *Summa de Summo Bono*, II, 3, 5. Quoted in LB.

which prevented it from shining forth in its full splendour. 'Every form is more ugly the less it possesses this light due to the obstruction of matter, and more beautiful the more it possesses this light due to its elevation above matter.'[3] It should not be necessary to stress the gulf in thought separating Ulrich and Aquinas.

St. Bonaventure also expounded an aesthetics based upon hylomorphic principles. But, as we have already seen, he developed it within the broader context of a metaphysics of light. As well as this he produced an aesthetics of proportion, influenced by Augustine's *De Musica*. This aesthetic is notable, not for its originality, but because Bonaventure declared that the laws of *aequalitas* (smoothness, evenness, uniformity) could be discovered by the artist in the depths of his own soul. Bonaventure, and the Franciscan school as a whole, provided valuable insights into the nature of artistic inspiration, rather than into the nature of the organism.

Ramon Llull held views that were somewhat similar to those of Aquinas. In his *Ars Magna*, for instance, he argued that the beauty of size (*magnitudo*) was based upon the principle of integrity; and the same applied to smaller proportions, as in the case of children. But Llull's thinking was moving already in a different direction. He regarded the world as something organic, but his metaphysics pertained neither to the mythical cosmology of the *Timaeus* nor to the rational and naturalistic world of Aquinas. Rather, it contained an element of magic and cabalism, and looked forward to the Platonism of the Renaissance.

A chain of concordances extends from the highest to the lowest. For there is a kind of universal affection among all things, in which they all share. It is a connection which many people, such as Homer, call the golden chain, or the cincture of Venus, a chain of nature or a token which things have towards one another.[4]

2. If we are looking for a development of the Thomistic theory – a real development, not just a repetition – we must turn to Duns Scotus. It is necessary to examine a number of passages from his works,

[3] ibid.
[4] Quoted in M. Menéndez Y Pelayo, *Historia de las ideas estéticas en España*, I, chap. 4.

for, with the exception of a few interesting asides, his aesthetics is mingled with his metaphysics and epistemology.

Scotus's definition of beauty differs in small but important details from any we have come across so far. 'Beauty is not some kind of absolute quality in the beautiful object. It is rather an aggregate [*aggregatio*] of all the properties of such objects – for example, magnitude, shape and colour, and the sum of all the connections between themselves and between themselves and the object.'[5] In this theory, beauty is based upon relations; and the concept of *aggregatio* acquires a particular meaning from Scotus's theory of the multiplicity of form. For Scotus, any composite object is actual because of the actualisation of its parts. Its unity depends, not upon the unity of its form, but upon a natural subordination of partial forms to the ultimate form. 'Thus the being of a composite whole includes the being of all its parts, and the partial being of many parts or forms. Hence the total being of a thing includes the partial actualisations of many forms.'[6] For Aquinas, when a number of forms converge to produce a 'mixed' body, the human body for instance, they lose their own proper substantial form. The body is invested with a new substantial form, that of the compound. In the human body, this is the soul. The constitutive substances retain their former autonomy only in the shape of certain *virtutes* or qualities, which are properties of the new compound. In maintaining the unity of substantial form, Aquinas was led to the view that an organism was above all something unitary. Scotus's theory of the multiplicity of forms, however, meant that his aesthetics had a relational bias. It led him to a more analytical, less unitary conception of beauty.

Another original element in Scotus, although he did not use it in connection with aesthetics, was his theory of *haecceitas*, or 'thisness'. *Haecceitas* is an individuating property. Its function is not the completion of a form, but the conferring of concrete individuality upon a compound object. In the Thomistic perspective, perceiving an organism means perceiving it as an instance of a *quidditas*, that is as something of a certain type, something which exemplifies a category. Whereas for Scotus the individual object is just itself. The principle of

[5] *Opus Oxoniense*, I, 17, 3, 13.
[6] *Opus Oxoniense*, IV, 11, 3, 46.

individuation does not *combine* with a thing; it is not logically distinguishable from it. Rather, it is a principle which completes a thing in its concreteness: 'the ultimate specific difference is simply to be different from everything else'.[7] For Scotus even more than for Aquinas, the individual transcends its essence; it is a more perfect entity not only because it has existence, but also because it is particularised and uniquely determined. Something is included in the nature of the individual (*ratio individui*) which is lacking in shared nature (*natura communis*): 'it includes positively being something [*entitas positiva*]. This makes it one with nature. Therefore nature is predetermined to singularity.'[8]

The concept of *haecceitas*, of absolute particularity, of the uniquely individual, is very much a living idea for the modern sensibility. Scotus did not use it in the context of aesthetic discussion, yet it clearly represented a philosophical responsiveness to his cultural environment – an environment in which there was a rethinking of values, a culture whose clearest expression was late Gothic and the new Primitives.

Early Gothic – that of Chartres or Amiens – expressed a sensibility eager to discern the form shining forth in objects, and to impose unity on multiplicity. But thirteenth century Gothic was more concerned with the particular than with ensembles. Its vision was more analytic. It was enthralled by multiplicity. This vision received its most extreme expression in the late medieval period, with the miniaturists and painters of France and Flanders. It is not too fanciful to interpret this as a realisation of the Scotist notion of relational form, form made up out of other, autonomous forms. Sensitivity to the type was being replaced gradually by a sensitivity to the individual. They began to abandon modes of sculpture aimed at producing conventional images of human species and categories, and to treat things as individuals with unique and unrepeatable qualities. We know some of the social and cultural factors which contributed to this change, but what is more striking still is that a metaphysics which arose within what seemed to be sterile controversies among the Schools, was in fact responsive to the cultural climate of the time.

[7] *Opus Oxoniense*, II, 3, 6, 13.
[8] *Opus Oxoniense*, II, 3, 6, 2.

Whether it influenced this culture or was influenced by it, there was certainly a fruitful relation between them.

The doctrine of *haecceitas* pointed in a direction that Scotus and his contemporaries were unable to follow. 'Thisness' must be grasped by the intuition, not the abstractive intellect; intellect sees it confusedly only, and must fall back on universal concepts.[9] Thus, the notions of individuality, irreducibility and originality combine with that of an intuitive cognition. There is no need to underline the aesthetic relevance of these ideas; the history of aesthetics itself does that for us. But their appearance had one consequence which should be mentioned. It was no longer possible for an organic conception of beauty to survive, at least not in the terms used by the Scholastic systems. The theory that perception was analytic, and a sense of the qualitative individuality grasped in intuition, were two poles between which the Thomist aesthetics of the organism came to grief.

The Thomist theory was also foreign to the thinking of William of Ockham, despite his glancing references to traditional ideas. According to Ockham, created things are absolutely contingent, and there is no regulation of things by Eternal Ideas in the mind of God. There is no stable cosmic order to which things conform, or which governs our mental dispositions, or which might inspire the craftsman. The order and unity of the world are not a sort of chain binding bodies together (*quasi quoddam ligamen ligans corpora*). Bodies are absolutes, numerically distinct (*quae non faciunt unam rem numero*), separated in a quite contingent fashion from one another. The concept of order refers to their position with respect to one another, not to some sort of reality implied in their essences.[10] The concept of the organising form of a thing, as a rational principle which informs it but is distinct from its constitutive parts, has gone. The parts are disposed in a certain way, and 'there is no object other than those absolute parts'.[11] The concept of proportion is thus impoverished, although Ockham did speak of the proportion of parts to the whole.[12] The reality of universals, which was necessary to the

[9] *Opus Oxoniense*, IV, 45, 3, 17 and 21.
[10] William of Ockham, *Quodlibeta*, VII, 13.
[11] *In I Sent.*, XXX, 1.
[12] *In I Sent.*, XXV, 5.

concept of *integritas*, was dissolved by nominalism. The problem of the transcendental status of beauty, and of the distinctions which specify beauty, can scarcely be posed in a system in which there are no such distinctions, neither formal nor virtual. All that remains is the intuition of particulars, a knowledge of existent objects whose visible proportions are analysed empirically; in fact, Ockham held that an intellectual intuition of particulars *is* possible.[13] As for artistic inspiration, this consists in an idea of the individual object which the artist wants to construct, and not of its universal form. Ockham's theories were full of possibilities which others were to develop; but he was the Scholastic who eliminated all of the principles necessary for the definition of beauty in Scholastic terms.

Nicholas of Autrecour carried these ideas still further, through his critique of the concepts of causality, of substance, and of finality. He argued that a cause cannot be known from its effects; that one thing cannot be an end for another; that there are no hierarchical degrees of being; that things are not more perfect than other things but are merely different from them; and that the judgments in which we arrange being in a hierarchy are just expressions of personal preference. Granted such premises, it was no longer possible to speak of organic structure, of the harmonious dependence of things upon one another, of adequacy to an end, or of an order of proportion. It was impossible to establish a causal relation between a first perfection and a second perfection, or a completing of the one by the other.[14]

All of these thinkers opened new pathways for science and for philosophy. But they also made it necessary to look for new aesthetic concepts, quite different from those on which the whole medieval period had in one way or another depended. In a universe of particulars, beauty had to be sought in that uniqueness of the image which is generated by felicity or genius. Renaissance aesthetics would again be Platonic, but the philosophical critique of the Ockhamists was a prelude to the aesthetics of Mannerism. Still, if their outlook made a metaphysical beauty impossible, they failed all the same to follow through its consequences for aesthetic theory. If man no longer sees a

[13] *In Lib. Sent.*, Prologue, 1.
[14] See Hastings Rashdall, 'Nicholas de Ultricuria, a Medieval Hume', *Proc. Aristotelian Soc.*, VII (1907), pp. 1–27.

given order in things, if his world is no longer encompassed by fixed
and definite meanings, relations, species and genera, anything then is
possible. He finds that he is free, and by definition a creator.[15] The
philosophers immersed themselves in the polemics of a declining
Scholasticism, or, like Ockham, flung themselves into the political
battles of a social order in the throes of renewal. The aesthetic ques-
tions, questions about creativity and the nature of the artist, were
left to others.

3. Late Scholasticism wreaked havoc upon the metaphysics of
beauty. The mystics, who were the other philosophical and religious
force of the age, were unable to rally or advance. The German and
French mystics of the fourteenth and fifteenth centuries had some
useful things to say about poetic creation, at least by way of analogy,
and we shall look at this later on. And they were always talking
about the beauty which they experienced during their ecstasies. Yet
they had nothing positive to say. Since God was ineffable, calling
Him beautiful was like saying that He was good, or infinite: beauty
was just a word used to describe the indescribable, so describing it by
what it was not. Their experiences left them with the feeling that
they had enjoyed the most intense delight, but a delight without
feature or character. They took great pleasure also in the kind of
experience where the intellect, filled with love, began with the con-
templation of earthly beauty and then soared aloft to God. This had
been a staple of the twelfth century and had led to the Victorine aes-
thetic, which was a fruitful and forceful one. But how could anyone
contemplate the *tranquillitas ordinis*, the beauty of the universe, the
harmony of the divine attributes, if God was seen as a fire, an abyss, a
food offered to an insatiable appetite? 'If God', said Ruysbroeck,
'were to give everything to the soul, other than Himself alone, its
spiritual lust would remain unsatisfied'.[16] Nothing could have been
further from the free delight of the intellect which had characterised
the preceding centuries.

Dionysius the Carthusian tells us that he was transported 'to a

[15] See Eugenio Garin, *Medioevo e Rinascimento*, 2nd edition (Bari, 1961), p. 38.
[16] Jan Ruysbroeck, *L'Admirable*, translated by Ernest Hello (Paris, 1902), p. 39.

sphere of infinite light', to an 'ineffable tranquility', where the 'incomprehensible God' was 'like a vastest desert, perfectly flat and incommensurable, in which the heart that is truly holy . . . can wander without losing itself, can succumb with blessedness and yet be healed'.[17] Suso wrote about a bottomless abyss of all things that give delight. Eckhart also spoke of an abyss, in which there was no sense or form of divinity; the soul was silent and alone. The soul, he claimed, attains to the highest beatitude by casting itself into the secrecy of God, where there is neither doing nor imagining. And Tauler also talks about this abyss, where the soul loses itself, loses even its self-consciousness, together with its consciousness of God, of distinctions, of identity, and of everything. In union with God, all distinctions vanish. There are neither doings nor imaginings nor distinctions nor relations nor knowledge. The last of the medieval mystics had nothing to say about beauty, nothing whatsoever.

This was a period of transition, between the aesthetic theories of the thirteenth century and the Renaissance. During this time it was the artists, ranging all the way from Dante to the troubadours, filled with a sense of their power and displaying a new and proud individuality, who added to the history of aesthetic feeling and theory.

[17] Dionysius the Carthusian, *Opera Omnia* (Tournai, 1896–1913), I, p. 44.

IX. Theories of Art

1. THE most anonymous chapter in any account of medieval aesthetics must surely be the one about the theory of art. The medieval conception of art was rooted in, and indeed was more or less the same as, the Classical and intellectualist theory of human 'making'; though of course there were many characteristic fluctuations which closer analysis brings to light. Definitions such as *ars est recta ratio factibilium*,[1] or *ars est principium faciendi et cogitandi quae sunt facienda*,[2] have no definite paternity; the Medievals just repeated and reformulated them in various fashions. From the Carolingians to Duns Scotus, they took their conception of art from Aristotle and from the whole Greek tradition: from Cicero, from the Stoics, from Marius Victorinus, from Isidore of Seville, from Cassiodorus.

The definitions given above refer to two basic elements: knowledge (*ratio*, *cogitatio*) and production (*faciendi*, *factibilium*). The theory of art was based upon these. Art was a knowledge of the rules for making things. The rules were given, objective – on this all the Medievals agreed. Cassiodorus, liberal as always in etymology, said that art was so called because it delimits or circumscribes (*arctat*),[3] and John of Salisbury repeated this derivation some centuries later.[4] But *ars* was also related to the Greek *aretēs*, according to both Cassiodorus and Isidore of Seville.[5] It was a power, a capacity for making something, and thus

[1] S.T., I–II, 57, 4.

[2] Alexander of Hales, *Summa Theologica*, II, 12.

[3] Cassiodorus, *De Artibus et Disciplinis Liberalium Litterarum*, Preface (PL, 70, col. 1151).

[4] John of Salisbury, *Metalogicon*, translated by Daniel D. McGarry (Berkeley and Los Angeles, 1962), I, 12.

[5] Isidore of Seville, *Etymologiae*, edited by W. M. Lindsay (Oxford, 1911), I, 1.

a *virtus operativa*, a power of the practical intellect. Art belonged to the realm of making, not of doing. Doing pertained to morality, and was subject to the regulative virtue of Prudence. There was something of an analogy between art and Prudence, according to the theologians; but Prudence governs the practical judgment in those contingent situations where it seeks and labours for the good, whereas art regulates those operations whose purpose is to beget an end product – operations on physical materials, such as sculpture, or upon mental materials, as in Logic and Rhetoric. Art aimed to produce a goodness of the work (*bonum operis*). The important thing for the craftsman was that he should make a good sword, for example, and it was not his concern whether it was used for good or evil purposes.[6] Thus, the two principal features of the medieval theory of art were intellectualism and objectivism: art was the science (*ars sine scientia nihil est*) of constructing objects according to their own laws. Art was not expression, but construction, an operation aiming at a certain result.

It meant construction, whether it was of a ship or of a building, a painting or a hammer. The word *artifex* applied alike to blacksmiths, orators, poets, painters, and sheep-shearers. This was another and a well-known feature of the medieval theory of art: *ars* was a concept with a broad extension, applying to what we think of nowadays as technology and artisanry. In fact, its theory of art was first and foremost a theory of craftsmanship. The artificer (*artifex*) constructed something that completed, integrated, or prolonged nature. Man was an artist because he possessed so little: he was born naked, without tusks or claws, unable to run fast, with no shell or natural armour. But he could observe the works of nature, and imitate them. He saw how water ran down the side of a hill without sinking in, and invented a roof for his house.[7] 'Every work is either the work of the Creator, or a work of Nature, or the work of an artificer imitating nature.'[8]

But if art imitates nature, this does not mean a servile copying of natural objects. It is inventive, and requires ingenuity. Art joins together what is separate and separates what is joined; it prolongs

[6] S.T., I–II, 57, 3.
[7] Hugh of St. Victor, *Didascalicon*, I, 9.
[8] William of Conches, *Comm. in Timaeum*. Quoted in ET, II, p. 266.

the operations of nature; it is productive just as nature is productive, and continues its creative labours. *Ars imitatur naturam*, it is true, but precisely 'in its manner of operation' (*in sua operatione*).[9] This second phrase is an important element in a formula which is often thought to be more banal than it really is. The medieval theory of art is interesting precisely for this reason, that it was a theory of the formative energies of human technology, and of the relation between this and the formative energies of nature.

One of the most fruitful analyses of this relation is in John of Salisbury's *Metalogicon*. Here he argues that art gives man the ability to realise possibilities inherent in nature, that he improves upon it and produces things better than nature herself:

> It substitutes for the spendthrift and roundabout ways of nature a concise, direct method of doing things that are possible. It further begets (so to speak) a faculty of accomplishing what is difficult. Therefore the Greeks also call it *methodon*, that is, so to speak, an efficient plan, which avoids nature's wastefulness, and straightens out her circuitous wanderings, so that we may more correctly and easily accomplish what we are to do. However vigorous it may be, nature cannot attain the facility of an art unless it be trained. At the same time, nature is the mother of all the arts, to which she has given reason as their nurse for their improvement and perfection.[10]

Nature, for its part, encourages the mind's genius (*vis quaedam animo naturaliter insita, per se valens*)[11] for perceiving and memorising objects, for examining and systematising them. Art and nature encourage one another mutually in this continual process of growth. When John of Salisbury used the term 'genius' (*ingenium*) it did not have the meaning it was to have for the Mannerists. For him it meant no more than a capacity for working (*virtus operandi*). But when he used the term 'nature' his meaning belonged to the cultural climate of the twelfth century. Nature meant something living and organic, an agent of God, an active matrix of forms.

[9] S.T., I, 117, 1.
[10] John of Salisbury, *Metalogicon*, I, 11.
[11] ibid.

2. In the thirteenth century this conception of art, as something bound up with the energies of nature, came to be curtailed. There developed an ontology of artistic form which imposed limits on the possibilities of art, and thus ensured that the orthodox medieval concept of art was something quite opposite to Goethe's *Schöpfertung*. For Aquinas, there was a profound ontological difference between natural and artistic organisms. The form introduced into matter by the artist was accidental rather than substantial form. The matter available to the artist was not pure potency, matter *ex qua*; rather, it was already substance, already act. It was matter *in qua*, such as marble, bronze, clay, or glass. It could assume various accidental forms, which shaped it into images but left its substantial nature intact.[12] 'Art', Aquinas wrote, 'operates on material furnished by nature'.[13] He gave the example of a lump of copper used to make a statue. As copper, it possesses merely a potency for the statue that will be made out of it; it is *infiguratum, privatio formae*. But this artistic form modifies it only superficially – for, its being copper does not depend upon an accidental form.

This argument shows how far the Mediêvals were from any conception of art as a creative force. At best, art could produce beautiful images, arrangements of the material which were superficial only. But it had to preserve a kind of ontological humility before the primacy of nature. The objects produced by art did not introduce a new order, but remained within the limits of their substance. They were simply 'reductions to images by means of measurement'.[14] They existed by virtue of the material which sustained them, whereas natural objects existed by virtue of divine participation.[15]

For St. Bonaventure also, 'The soul can make new compositions, but it cannot make new things'.[16] He said that there were three forces operative in the world: God, who creates out of nothing; Nature, which operates on potential being; and art, which operates on Nature and presupposes existing things (*ens completum*).[17] The artist, he said,

[12] This argument is expounded at length in Aquinas's *De Principiis Naturae*.
[13] *Comm. de Anima*, II, 1, 218.
[14] S.T., II, 2, 1.
[15] *Summa Contra Gentiles*, III, 64.
[16] St. Bonaventure, *In III Sent.*, 37, 1, dub. 1.
[17] *In II Sent.*, 7 (pars 2), 2, 2.

can do nothing to the substance of things.[18] 'In manufactured things
... there is no positive impact of an agent on a recipient, but only a
local modification or change.'[19] The artist can help or hasten the pro-
ductive rhythm of nature, but he cannot compete with it.

These ideas were taken up in popular Scholasticism and in popular
opinion, and became part of the general knowledge of the time. In
the *Roman de la rose* Jean de Meun (who wrote his part of the poem
shortly after Aquinas's *Summa*) wrote a passage dealing with Nature's
concern for the preservation of the species, and in the middle of this
passage he made a long digression on the nature of art. Art, he said,
does not produce true forms like Nature. Rather, it must go on its
knees before Nature (like a beggar, poor in learning but desirous to
imitate her), and ask her to teach him how to capture reality in his
images. But even when imitating the works of Nature, art cannot
create living things. Here, the ontological distrust of the philoso-
phers becomes the ingenuous disillusion of someone who sees that
art can create 'knights on magnificent chargers, all clothed in armour
of blue, of yellow or green, or striped with other colours; birds in
the verdure; the fishes of all the oceans; savage beasts browsing in the
forests; all the plants and flowers that children and young people go
to gather in the woods in spring' – it can create all of this, yet cannot
make them move or feel or speak.

We should not think of this as a sensibility blind to the true nature
and value of art. Jean de Meun's concern, like Aquinas's, was to spe-
cify the possibilities of art and nature on the scientific rather than the
aesthetic level. It was quite natural that for the purposes of his argu-
ment he should neglect the latter. The difference between Aquinas
and Jean de Meun lay elsewhere. For the poet, his argument was in
fact meant to demonstrate the superiority of alchemy to art; for
alchemy, it was believed, could transmute substances. We see here
that even though the secular culture of the time made use of Scholas-
tic methods and concepts, it contained the beginnings of the science
and philosophy of Renaissance humanism.

Despite all its limitations, the ontological theory of artistic form
established an unequivocal connection between the aesthetic and the

[18] *In II Sent.*, 1, 2 ad 2.
[19] *In II Sent.*, 7 (pars 2), 2, 2.

artistic. Both were grounded in concepts of form. Aquinas suggested that we find artistic forms congenial, and thus easily compassed in aesthetic experience, because they do not require us to comprehend and penetrate to the heart of the complexities of substance. Artistic forms are empirical, superficial.[20]

3. Despite the fact that they connected the artistic with the aesthetic, the Medievals had only a scanty understanding of the *specifically* artistic. They lacked a theory of the fine arts. They had no conception of art in the modern sense, as the construction of objects whose primary function is to be enjoyed aesthetically, and which have the high status that this entails. They found it difficult to define and order the various kinds of productive activity, and this is why the attempt to construct a system of the arts underwent so many vicissitudes.

Aristotle distinguished between the servile and liberal arts,[21] and the idea of a system of the arts came to the Middle Ages from Galen's *Perì Téchnēs*. Several medieval authors proposed such systems, among them Hugh of St. Victor, Rudolf of Longchamp, and Domenico Gundisalvi. Gundisalvi expounded his system, which was Aristotelian in type, in 1150.[22] He said that Poetics, Grammar, and Rhetoric were superior arts, under the common name of Eloquence. The mechanical arts were lower in kind.[23] It was generally believed, in fact, that the servile arts were compromised by their material character and the physical labour involved. Aquinas said that the manual arts were servile, and that the superiority of the liberal arts was due to their rational subject-matter and their being arts of the mind rather than the body. It was true that the liberal arts did not have the productive character of art as it was defined in the abstract; but they were arts all the same 'because of a certain analogy' (*per quandam similitudinem*).[24] In fact this led to a paradox. As Gilson acutely

[20] S.T., I, 77, 1 ad 7.

[21] Aristotle, *Politics*, VIII, 2.

[22] Domenico Gundisalvi, *De Divisione Philosophiae*, edited by Ludwig Baur (Münster, 1903).

[23] Some writers justified this view by claiming that the word *mechanicae* derived from the verb *moechari*, to commit adultery. This etymology reappears even in Hugh of St. Victor, *Didascalicon*, I, 9.

[24] S.T., I–II, 57, 3 ad 3.

remarks, art arose when the reason became interested in *making* something; the more it made the more was there an art. And yet, the more it was involved in making, the essence of art, the more servile it became, and the more the art was a minor one.[25]

This kind of theory expressed an aristocratic viewpoint. The distinction between servile and liberal arts typified a mentality for which the highest goods were knowledge and contemplation, goods of the intellect. It reflected the values of a feudal and aristocratic society, just as in Greece it had reflected an oligarchical society, in which manual work, usually for wages, inevitably seemed inferior. Social factors made this theory so tenacious that even when its premises were no longer true it still remained, a stubborn prejudice, giving rise in Renaissance times to furious arguments about the status of the sculptor.

Perhaps the Medievals remembered Quintilian: 'The learned understand the nature of art, the unlearned its voluptuousness'.[26] Artistic theory provided definitions of art in terms of what could be experienced by the learned, while artistic practice and pedagogy had to do with *voluptas*. Any possible distinction between fine art and technology was swamped by the distinction of liberal and servile arts; and yet, the servile arts were considered as fine arts whenever they were didactic, purveying truths of faith or of science through the pleasures of the beautiful. The Synod of Arras pronounced, 'Unlettered people, who cannot appreciate this through reading Scripture, can grasp it in the contemplation of pictures'.[27] And Bernard Silvestris said of poetry, 'Under cover of narrative fable, it is a kind of demonstration of truths of the intellect'.[28]

The idea of an art designed simply to give pleasure is mentioned only casually. St. Thomas Aquinas expressed approval of women's hairstyles and of games and diversions, also of verbal play and dramatic representations. Yet even here there were practical reasons. It is good, he said, that women should adorn themselves in order to

[25] Etienne Gilson, *Painting and Reality* (London, 1957), p. 31.

[26] Quintilian, *Institutio Oratoria*, IX, 4.

[27] Synod of Arras, chap. XIV, in *Sacrorum Conciliorum Nova et Amplissima Collectio*, edited by J. D. Mansi, 53 vols. (Paris & Leipzig, 1901–27), XIX, p. 454.

[28] Bernard Silvestris, *Commentary on the Aeneid*, Prologue, edited by Julian Ward Jones and Elizabeth Frances Jones (Lincoln and London, 1977), p. 3.

cultivate the love of their husbands; and games give delight 'in that they lighten the fatigue of our labours'.[29]

4. Despite these limitations, it is still possible to extract some views and conceptions of fine art from medieval aesthetics. There is an important passage in this connection in the *Libri Carolini*, a work written for the Court of Charlemagne, once ascribed to Alcuin but now to Theodulf, Bishop of Orleans.[30] It had roots in the Council of Nicea, which in the year 787 expressed approval of the use of sacred images, and thus rejected Iconoclasm. The Carolingian theologians supported the Council's view, but they did so in a number of rather subtle observations on the nature of art and of images. They argued that while it is foolish to adore sacred images, it is just as foolish to destroy them as something dangerous. Images have their own sphere of autonomy, which makes them valid in their own terms. Images are *opificia*, manufactured objects, the material products of secular art, and should have no mystical function. No supernatural force inspires them. No angel guides the artist's hand. Art is neither sacred nor heathen, but neutral. There is nothing to adore or venerate in images, for they are simply products of the artist's genius. 'Images grow in beauty and are in a measure altered by virtue of the artist's ingenuity.'[31] The value of an image resides, not in representing a saint, but in being made well and out of a worthy material. In the case of an image of the Virgin and Child, it is only the title written beneath it that tells us it is religious. In itself, it merely represents a woman with a child in her arms, and could just as well be Venus and Aeneas, Alcmene and Hercules, or Andromache and Astyanax. If there are two images, one of which represents the Virgin Mary and the other a pagan goddess, 'both are equal as figures, equal in colour, equal in material; only the titles are different'.[32]

This vigorous affirmation of artistic autonomy contrasts strongly with Suger's theory of allegory and his poetics of the cathedral. The

[29] S.T., I–II, 32, 1 ad 3.
[30] *Libri Carolini*, PL, 98, cols. 941–1350.
[31] *Libri Carolini*, II, 27 (PL, 98, col. 1095).
[32] *Libri Carolini*, IV, 16 (PL, 98, col. 1219).

aesthetics of the *Libri Carolini* was one of pure visibility, and at the same time an aesthetics of the autonomy of the figurative arts. Of course, it is only one aspect of Carolingian culture that finds expression here; in fact the Carolingian period is marked by repeated condemnation of pagan fables. Nevertheless, the passage just discussed is filled with references to works of art, pottery, stuccoes, pictures and illustrations, and work in precious metals, which testify to the sophisticated tastes of its author. The Carolingian Renaissance was also notable for its love of classical poetry, indicating a humanistic sensibility whch was already very articulate.

While the theologians were developing this skeletal theory of art, there arose a voluminous technical literature concerned with artistic precept and practice. Two of the earliest of these manuals were *De Coloribus et Artibus Romanorum* and *Mappa Clavicula*. Here, technical points mingled with echoes of Classicism and with the fantasies of the Bestiary.[33] But these treatises, and others like them, were rich in observations of relevance to aesthetics. They show a clear awareness of the connection between the aesthetic and the artistic, and were filled with observations on colour, light, and proportion.

Then in the eleventh century there appeared the well-known *Schedula Diversarum Artium*. Written by a cleric called Theophilus, it was discovered by Lessing in the Library of Wolfenbüttel.[34] Theophilus wrote that, since man is created in the image of God, he has the power to give life to forms. He discovers his need for beauty both by chance and by reflection on his own soul, and by practice and endeavour he develops his artistic powers. He finds in the Scriptures a divine commandment on art where David sings, 'Lord, I have loved the beauty of Thy house'. These words are a clear directive; the artist must work in humility, inspired by the Holy Spirit, for without this inspiration he could not attempt his work. Anything that he can invent or learn or understand about art is the fruit of the Seven Gifts of the Holy Spirit. Through Wisdom he understands that art comes to him from God; through Understanding he comes to know the rules of variety and measure; through Counsel he is willing to pass

[33] See J. Schlosser-Magnino, *Die Kunstliteratur* (Vienna, 1924), pp. 26f.
[34] Theophilus, *De Diversis Artibus* (*Schedula Diversarum Artium*), edited and translated by C. R. Dodwell (London, 1961).

the secrets of his craft on to his pupils; through Fortitude he achieves perseverance in his creative struggles; and so on for the rest of the Seven Gifts. From these theological premisses, Theophilus proceeds to give a long series of practical precepts, particularly in connection with glasswork. He reveals also a very liberal taste in figurative art. For example, he recommends that the empty spaces between representations of great historial events should be filled with geometrical designs, flowers, leaves, birds, insects, and even little nude figures.

When the Medievals did reflect unsystematically upon the figurative arts, they undoubtedly said things that their systems were not able to encompass. Thus Alan of Lille, writing in his *Anticlaudianus* about the pictures decorating the palace of Nature, praised it as follows: 'Oh painting with your new wonders! What can have no real existence comes into being and painting, aping reality and diverting itself with a strange art, turns the shadows of things into things and changes every lie to truth.'[35]

Cennino Cennini gave a new value to the art of painting when he put it on a level with poetry, just behind knowledge. His view that painting reflects a free and constructive play of the imagination was influenced by the passage in the *Ars Poetica* where Horace wrote, 'Poets and painters alike have always had the right to take liberties of any kind'.[36] Another even more 'medieval' author than Cennini, William Durandus, expressly used this passage in Horace to justify pictures of events in the Bible.[37]

In this way, pictures began to acquire status, and the theologians helped by providing a theory which explained their beauty. Aquinas's argument centred around the image of images, the Son of God. Christ was beautiful because He was an image of the Father, an image being 'a form bestowed on something by someone else'.[38] The Son of God thus possessed the three attributes of beauty. He had integrity in that He realised His Father's nature in Himself; harmony because He was 'a clear image of the Father' (*imago expressa Patris*); and clarity because He was the Word, expression, *splendor intellectus*.

[35] Alan of Lille, *Anticlaudianus*, translated by James J. Sheridan (Toronto, 1973), I.

[36] Horace, *Ars Poetica*, 9–10.

[37] William Durandus, *Rationale Divinorum Officiarum*.

[38] S.T., I, 35, 1 ad 2.

St. Bonaventure was more explicit still. He distinguished two reasons for the beauty of an image, even when the object imitated was not beautiful in itself. An image, he said, was beautiful if it was well constructed, and if it faithfully represented its object. 'An image of the devil can be called "beautiful" if it is a good representation of his foulness and thus foul itself.'[39] The image of something ugly is beautiful when it is 'ugly' in a persuasive manner: here was the justification of all the figures of devils in cathedrals, and the critical foundation of that unconscious pleasure which St. Bernard's condemnations revealed.

5. There were treatises also on poetry and Rhetoric. Poetics had long been confused with Grammar and Metrics. The idea of an art of poetry reappeared in Domenico Gundisalvi's *De Divisione Philosophiae*, but on the whole the place of Poetics was taken by rules of oratory (*artes dictamini*), to which prose and poetry alike were subject. As Curtius notes, there were no words for referring to the writing of poetry; the concepts of metrical composition, verse, or writing in metre, were expressed by Adhelm of Malmesbury and Odo of Cluny as 'metrical eloquence' (*metrica facundia*) or 'written texts designed for poetic dicta' (*textus per dicta poetica scriptus*), and other expressions of the same type.[40]

The real critical awakening came in the twelfth century. For instance, John of Salisbury recommended that in reading the *auctores* – that is, men of letters – we should follow the critical methods of Bernard of Chartres.[41] At this time, too, a distinction arose between the 'new poetry' and ancient poetry; and controversies arose among various literary movements, such as the verbal purists, the School of Orleans, the antitraditionalists, and so on.[42] In the twelfth and thirteenth centuries Matthew of Vendôme, Geoffrey of Vinsauf, Eberhard of Bethune, and John of Garland devised theories of the art of poetry which, though philosophically weak, are important in the

[39] St. Bonaventure, *In I Sent.*, 31 (pars 2), 1, 3, ad 2.
[40] See E. R. Curtis, *European Literature and the Latin Middle Ages*, chap. 8.
[41] *Metalogicon*, I, 24.
[42] See G. Paré, A. Brunet and P. Tremblay, *La Renaissance du XIIe siècle* (Ottawa, 1933).

history of medieval Poetics and were not without relevance for aesthetics. They gave many traditional precepts about symmetry, verbal colour (*color dicendi*), *festivitas* or 'playfulness' in language, and the rules of composition; but they also came up with some novelties. Geoffrey of Vinsauf, for instance, spoke about the hardness and resistance of the material, which only strenuous effort could render docile to the required form.[43] This was a view which philosophical theories of art tended to deny, suggesting instead that there was no difficulty in imposing artistic form on the material.

It was in the twelfth century also that Averroes expounded a Poetics of spectacle, supplemented by some remarks about poetry. His treatment of the Aristotelian ideas involved was not very original but his distinction of poetry and history was different from Aristotle's, and new to the Middle Ages. He said that an author who recounts tales, rather than history, makes an inventory of facts without giving them any order; whereas the poet gives measure and rule – that is, poetic metre – to facts both true and verisimilar, and he deals also with universals. Hence poetry is more philosophical than a simple imaginative chronicle. Another interesting remark was that poetry should not employ the weapons of rhetoric or persuasion. It should simply imitate, and it should do so with such vivid liveliness that the object imitated appears to be present before us. If the poet discards this method for straightforward reasoning, he sins against his art.[44]

Under the impact of secular poetry, Scholasticism was starting to reflect some awareness of the new outlook expressed in word and image. It came to be seen that poetry involved something more than just the use of metre. Alexander of Hales, faithful to the orthodoxy of the Schools, maintained that poetry was something 'contrived and not involving knowledge' (*inartificialis sive non scientialis*).[45] But the poets themselves knew of a new type of knowledge, poetic knowledge.[46] The troubadours had a Poetics of inspiration. Juan de Baena, in the prologue to his *Cancionero*, said that making poetry was a grace

[43] See Edmond Faral, p. 203.
[44] M. Menéndez y Pelayo, pp. 310–44.
[45] *Summa Theologica*, I, 1.
[46] See M. Menéndez Y Pelayo, p. 416.

given by God. Poetry, for him, followed the path of subjective state-
ment, of feeling.

Geoffrey of Vinsauf declared that reason should control the hand
of the impetuous, and regulate our actions according to a precon-
ceived design.[47] But Chrétien de Troyes tells us that when Percival
leaps upon his horse in full armour he ignores the knight who is
instructing him, and his advice that every art needs long and con-
stant applicaton. Percival, who knows nothing of the Scholastic
theory of art, sets his lance in its rest without fear: 'Nature herself
will instruct me; and when Nature wishes it, aided by the heart,
nothing is difficult'.

[47] *The New Poetics*, p. 34.

X. Inspiration and the Status of Art

1. LITTLE by little a new consciousness of the dignity of art, and of the value of poetic creativity, entered into medieval culture. Scholastic theory, however, was too rigid to assimilate conceptions such as these. At the same time, we must be careful not to find too much fault with it, as if there were nothing but distortion and condemnation.

For instance, Aquinas referred to poetry as 'inferior learning' (*infima doctrina*), and said that 'poetic matters cannot be grasped by the human reason because they are deficient in truth'.[1] But he did not mean to denounce it root and branch. He was simply repeating the conventional opinion about art, that it was a form of 'making' and so inferior to pure intellectual thought. In fact, the passage in question was a comparison between poetry and Scripture, so poetry had to be the loser. Poetry's 'deficiency in truth' referred to the fact that it is a non-scientific mode of discourse and deals with fictions. 'The poet', Aquinas wrote, 'represents things by means of metaphors . . . for representation is by nature something delightful to man.'[2] It followed that the object of poetic representation could not be an object of knowledge in a strict sense. For the rest, Aquinas was aware of the aesthetic and the hedonistic value of poetry. His remarks were not a condemnation, but reflected a theorist's lack of interest in the pleasures of poetry, especially if it does not have a didactic function. Conrad of Hirschau, in his *Dialogus super Auctores*, said that the poet is

[1] S.T., I–II, 101, 2 ad 2.
[2] S.T., I, 1, 9 ad 1.

called a *fictor* 'because he either speaks falsehood instead of truth or mingles the true with the false'.[3] He added that in poetic fables words often do not have any significative force, but are merely the sound of the voice (*sonum tantummodo vocis*).

Scholasticism, unlike modern theories, could not envisage the possibility that poetry might reveal the nature of things with an intensity and a breadth lacking in rational thought. This was because of its commitment to a didactic conception of art. If poetry did contain any truth that was independently verifiable, the most that it could do was to express it in a pleasing manner. It could not discover truth. The pagan poets, unaware of the truths of Revelation, could write of the truth only through some kind of divine inspiration. Seneca had written, 'Many poets write of things that the philosophers have said or that they ought to have said',[4] but the Medievals understood this in the most superficial sense – that poetry may contain some philosophical and scientific discussion. As Jean de Meun put it, composing poetry can sometimes be regarded as dabbling in philosophy.

Eventually, though, a new theory of poetry emerged, devised by proto-humanists like Albertino Mussato. Mussato said that poetry was a science, and a divine gift: 'it was a science sent down from heaven, just as law comes from God'.[5] The ancient poets, he added, were heralds of God, and in this sense poetry could be regarded as a kind of secondary theology. Aquinas had referred to Aristotle's distinction between the early cosmological poets, whom Aristotle called theologians, and the philosophers;[6] but Aquinas himself held that only philosophers (theologians in his view) were familiar with knowledge of the divine. Poets, by contrast, 'are liars, as the proverb has it'.[7] He was condescending about mythical poetry, that of Orpheus or the Muses. At best it might give us to understand, by way of similitude and fable, some notion such as water being the origin of things.[8]

[3] Conrad of Hirschau, *Dialogus Super Auctores*, edited by G. Schepss (Wurzburg, 1889), p. 24.

[4] Seneca, *Ad Lucilium Epistulae Morales*, VIII.

[5] Albertino Mussato, *Epistola IV*. Quoted in E. R. Curtius, p. 215.

[6] Aristotle, *Metaphysics*, 983b–984a.

[7] *Comm. in Metaph.*, 63.

[8] *Comm. in Metaph.*, 83.

But now the proto-humanists set out to add the somewhat dubious concept of the poet-theologian to Scholastic terminology. The idea originated in arguments with people who supported Aristotelian intellectualism, such as Fra Giovannino of Mantua. Hidden beneath apparently traditional views, they smuggled in an entirely new conception of poetry. Eugenio Garin describes it as,

> an endeavour to assign a revelatory function to poetry, to consider it as the centre and supreme moment of human experience . . . as the point at which man *sees* the true nature of his condition . . . identifying himself with, and participating in, the living rhythm of things, something at once capable of translating everything into images and yet also a form of human communication.[9]

This new feeling was implicit in secular poetry, and was explicit in a few of the early humanists. But Scholastic theory was closed to it. As for the poetry of the Scriptures, this was regarded as different, not meant as ornament, exact in its allegorical references, and in the end more than human. The visions of the mystics, their aesthetic ecstasies infused with faith and grace, were not perceived to have any similarity to poetic feelings. Didactic poetry, moreover, was never thought to be a more 'profound' kind of discourse than philosophy. The distinction of intuition and explanation was felt to be relevant only to the contrast between mysticism and philosophy, and not to the contrast between didactic poetry and philosophy.

Medieval theory of art was quite oblivious to this problem. Yet one cannot really cavil. The value of the theory lay in stressing other aspects of artistic endeavour. It handed on to posterity a firm grasp of the manual and constructive nature of art, and a consciousness of the artistic element in technology and the technical element in art. These are forgotten lessons to which aesthetics is once more starting to listen.

2. Medieval theory of art included discussion of another problem, although again it failed to do justice to new poetic practices and poetic self-consciousness. This was the problem of the artist's 'exemplary idea', the problem of artistic creativity.

[9] Eugenio Garin, *Medioevo e Rinasimento*, p. 50.

In Classical aesthetics, Plato's theory of Ideas had undergone a change. It was used initially for denigrating art, but became instead an explanation of the artist's interior phantasm. Hellenistic thought achieved a revaluation of artistic endeavour, and came to accept the view that art involved an idea or image of beauty not found in nature. Philostratus, for instance, believed that the artist could emancipate himself from natural models and even from habits of perception. It was the beginning of a concept of the imagination which was in turn the basis for an aesthetics of intuition.[10]

The Stoics contributed to this development. Cicero, in his *De Oratore*, sketched a theory of an interior phantasm which was superior to the objects of sense. In fact, if a beautiful object need only be an object created in thought, it follows either that it is less perfect than the actual forms of nature, or else that artistic ideas possess the highest metaphysical perfection. Plotinus, of course, held the latter view. For him, the interior Idea was a sublime and perfect prototype through which the artist enjoyed an intellectual vision of the fundamental principles of nature. The aim of art was to embody the Idea in a material, although this could be done only with an effort, and with only partial success. Matter resisted being shaped in this way.[11] Even more important in Plotinus, however, was his sense of the nobility of the artist's interior vision, this living exemplar in his imagination.[12]

All of the Medievals, whether Platonic or Aristotelian, believed that there were exemplary ideas in the artist's mind. They held that works of art were constructed in accordance with them, and did not worry unduly about how they were adapted for material embodiment. But how were they formed in his mind? Where did they come from? How did they appear to his consciousness?

According to Augustine, the mind has the power to add to or subtract from things, to alter the deposits left in the memory by experience. Thus, if we add to or subtract from the form of a raven, we

[10] See Augusto Rostagni, 'Sulle tracce di un'estetica dell'intuizione presso gli antichi', in *Scritti Minori*, 3 vols. (Turin, 1955), I, pp. 356–71.

[11] The relation of matter to Idea in Plotinus was, of course, quite different from the Aristotelian relation of matter and form.

[12] The historical development of this theory of an artistic Idea is dealt with fully in Erwin Panofsky, *Idea: a Concept in Art Theory*, translated by Joseph J. S. Peake (Columbia, 1968; orig. pub. 1924).

will imagine a creature that does not exist in nature.[13] In essence, this is the mechanism of imagination sketched out at the start of *Ad Pisones*. Augustine never moved far from an imitation theory of the imagination, despite all the possibilities opened to him by his innatism. The nearest approach to a medieval theory of inspiration was to be found, as we have already seen, in Theophilus's *Schedula Diversarum Artium*.

Nowadays the tendency is to believe that, while art has qualities of uniqueness, this is not attributable to its independence from nature and experience. We look upon art as a focus of lived experiences, given order and form by our normal imaginative processes. Artistic particularity arises from the *manner* in which the order and form are made concrete and offered to perception. There is a process of interaction among lived experiences, artistic decisions, and the autonomous laws of the material that is being used. Still, modern aesthetics has for long included some notion that there is an 'Idea' embodied in a work of art, and discussion of this has generated some penetrating insights. It therefore seems useful to trace the historical development of the notion. It descended to the Renaissance and to Mannerism from the Middle Ages; but in its most important formulation, the Aristotelian theory, the phenomenon of ideation was not explained satisfactorily. It failed to offer much to subsequent discussion.

For Aquinas, the artistic idea existed as an image in the artist's mind, 'an exemplary form in whose likeness something is constructed'.[14] Elsewhere he wrote, 'The operative intellect preconceives the form of what is made; it possesses the form of the thing imitated as an idea'.[15] It was an Aristotelian type of position: the idea in question was not an idea of the substantial form, of form as distinct from matter, a sort of Platonic essence. Rather, it was an exemplary idea of a form conceived of in its connection with matter, form as constituting a unity with matter. 'Thus, the idea properly speaking has to do neither with the matter nor the form, but with the whole composition; it is operative in both form and matter.'[16] The organism is

[13] St. Augustine, Letter 7 (to Nebridius), *Letters*, vol. I, pp. 14–19 (p. 18).

[14] St. Thomas Aquinas, *In III Sent.*, 27, 2, 4, 3 ad 1.

[15] St. Thomas Aquinas, *De Veritate*, 3, 2.

[16] *De Veritate*, 3, 5.

governed by a single exemplary form, and Aquinas stresses the unity of the composition. When the architect thinks of a building, he thinks of it with all its properties, its layout, its height, and so on. Only the secondary properties are thought of later, after the house has been built – the ornamentation, the murals, and the like. It is worth noting here again the strictly functionalist conception of art; the pleasurable accessories do not pertain to the true artistic idea.

The exemplary form can arise in the artist's mind because of the impulse to imitate, because he wants to reproduce an object in nature. But when it is a new object like a building, or a story or a statue of a monster, the exemplary idea is created by the *phantasia*, the imagination. Imagination is one of the four internal powers of the sensitive part of man (the others are the common sense, the estimative or cogitative power, and memory); it consists of a deposit of lived experiences, 'a kind of thesaurus of forms received by sense'.[17] Through imagination we can bring a remembered object before us as if it were actually there, or we can put a number of remembered forms together.[18] This putting together of forms is the most typical activity of the imagination, and does not have to be explained by reference to any other faculty.

> Avicenna places between the estimative and the imaginative a fifth power, which combines and divides imaginary forms: as when from the imaginary form of gold, and the imaginary form of a mountain, we construct the one form of a golden mountain, which we have never seen. But this operation does not take place in animals other than man, and in man the imaginative power is sufficient for this.[19]

This theory is openly empiricist and intellectualist. Its most positive features are its clarity and simplicity. It sets out to explain art without reference to the non-rational or the praeternatural. What is missing, however, is the more complex notion of the inventive powers of the imagination, which could in principle have been explained on the existing premises. And there is no sign of awareness

[17] S.T., I, 78, 4.
[18] *Comm. de Anima*, III, 4, 632–3.
[19] S.T., I, 78, 4.

that art, nourished by intellectual insight and skilled craftsmanship, involves an arduous process in which physical manipulations do not *follow* the conceptions of the intellect, but *are* the intellect conceiving something by making it. As Gilson asks, how can art, if it is a power of the intellect, imprint an idea on a material? The intellect cannot imprint things.[20] The artistic process, as conceived in Aristotelianism, is not spontaneous and does not lead to a unique act of creation. Aristotelianism ignores, in effect, the subjectivity and affectivity of art.

3. As the ideal of chivalry waxed, the basic medieval value of *kalo-kagathìa* acquired more aesthetic force. *Le Roman de la rose* is one example. Courtly love is another. Aesthetic values had been expressed in stylised formulae, applicable to human life interpreted in the light of the divine. Now they became social values. Woman stood at the centre of this social and artistic life. She had been ignored during Feudalism, but now acquired an inalienable place in literature. So the value attached to the emotions increased, and a poetry of events was superseded by a poetry of subjective statement. Much later, the Romantic movement falsified history in its fascination with things medieval; but it rightly detected there the germ of an aesthetics of feeling, the birth of a new sensibility fraught with unsatisfied passion (in Romanticism, the masochism of the *princesse lointaine*), which made poetry an expression of the indefinite. Though in fact, the new poetry of the courts and of the troubadours was quite conventional and allegorically rigid.

In the face of these ferments, the Scholastic theory of art was more or less at a loss. Even as it was it could only partly explain the fine arts, for it was confined to didactic art in which clear, pre-existing knowledge provided the exemplary idea and was expressed in accordance with rules. But when Dante says that he is expressing what Love has commanded him from within, we are faced with something quite different, even if Love is defined philosophically. We have quite a new conception of creativity, unambiguously tied to a world of passions and emotions. It heralds the modern aesthetic sensibility, with all its problems.

[20] Etienne Gilson, *Painting and Reality*, p. 32.

Only the mystics were able to furnish the new poetry with a way of explaining its thought, its feeling, and its intuitive character. Mysticism, of course, was concerned with other regions of the soul; but it contained the seeds of a future aesthetics of inspiration and intuition. Just as the Platonic tradition made possible a theory of artistic Ideas, so did the Franciscan emphasis on love and will provide the nucleus of an aesthetics of feeling. And St. Bonaventure's theory, that in the depths of the soul there exists a need for, and the rule of, a 'harmonious smoothness' (*aequalitas numerosa*), was significant also. It pointed to a way in which future aesthetics of artistic ideas and inspiration could define the interior phantasm.

As well as this Franciscan spirituality, there already existed in Victorine mysticism a possible basis for an aesthetic intuition. It was to be found in a distinction between intelligence and reason, where intelligence signified contemplation and synthesising vision: 'contemplation that is free as air, imbued in its motions with a wondrous agility'.[21]

Judeo-Arabic thought could also hint at an aesthetics of the imagination. Jehudah Levi, in his *Liber Cosri*, referred to the poet's heavenly gift of immediate interior vision, his insight. The rules of harmony are nurtured in his soul and are realised externally although he may not know how to formulate them. Some people might know all the rules of poetry and yet be unable to create any, while 'someone who is a poet by nature can produce delightful and impeccable poetry on the instant'.[22] This marked the end of Boethian intellectualism. For Avicenna also, the imagination rises above the solicitations of sense; its imprint comes from above and creates a perfect form, 'a discourse in verses or a form of wondrous beauty'.[23] And yet another point worth mentioning is the notion of the divine madness of poets. This pervaded the whole medieval tradition, although it was never taken up on the theoretical level.[24]

For Meister Eckhart, the forms of every created object exist first in the mind of God. So that whenever the imagination conceives of

[21] Richard of St. Victor, *Benjamin Major*, I, 3 (PL, 196, col. 66).

[22] Jehudah Levi (Yehudah Halevi), *Liber Cosri*, edited by J. Buxtorf (Basle, 1660), p. 361.

[23] Avicenna, *Livre des directives et remarques*, translated by A.-M. Goichon (Paris, 1951), p. 515.

[24] See E. R. Curtius, pp. 474–5.

some object, this is actually an illumination or intellectual grace; man's ideas are discovered rather than formed; everything conceived by man subsists in God Himself: 'words derive their power from the original Word'. Looking for an artistic exemplar does not mean setting out to create it. It means rather the mystical focusing of the attention upon the reality which is to be reproduced, to the point of identifying with it. But the ideas subsistent in God and communicated to men's minds are not Platonic archetypes so much as types of activity, forces, operative principles. They are living ideas. They do not exist as 'standards', but as ideas of actions to be done. An actual object emerges from the idea like something growing from it. Eckhart's theory is presented in a manner reminiscent of Aristotle, but it has more of a sense of the dynamism and generative power of ideas.[25] An image that has been expressed is 'an emanation of form' (*formalis emanatio*) and 'knows its own emerging forth' (*sapit proprie ebullitionem*). It is not distinct from the exemplar but shares the very life of the exemplar; it is in it and identical with it.

> An image, and the thing of which it is an image, are not separate; they are not two substances . . . An image is strictly an emanation, simple, formal, a pouring forth of the whole of an essence, pure and naked. It is an emanation from the depths, in silence, excluding everything exterior. It has a kind of life. A thing's image grows out of itself and grows upon itself.[26]

From these germinal ideas there arose a new vision of the artistic process. If we extrapolate them from the psychology of mysticism and the theology of the Trinity we can discern something that is not medieval any more, the germ of new directions in aesthetics akin to our own world.

4. While theorists were struggling with these problems, the artists themselves were already quite conscious of their own importance. Indeed, this awareness was never absent in the Middle Ages, although

[25] See Ananda Coomaraswamy, 'Meister Eckhart's View of Art', in *The Transformation of Nature in Art* (Harvard, 1934).
[26] A. Spamer, *Texte aus der Deutschen Mystik des XIV und XV Jahrhundert* (Jena, 1912), p. 7.

there were social, religious, and psychological factors which encouraged artists to cultivate attitudes of humility and a seeming desire for anonymity.

In the early Middle Ages there was widespread veneration for Tuotilo, the legendary monk who lived out his life as an artist in the Monastery of St. Gall. Tuotilo was considered to be a kind of universal artist: handsome, eloquent, with a pleasing voice, an expert on the flute and the organ, a brilliant orator and conversationalist, skilled in the figurative arts. He was, in short, the human and humanistic ideal of the Carolingian period. Abelard is witness to the same kind of outlook; he wrote to his son Astrolabius that the dead live on in the works of poets. There is an abundance of documentation which testifies to the honour paid to poets and artists.

Yet the ways in which this was manifested were often bizarre. The monks of Saint-Ruf, for instance, abducted at dead of night a young painter whom the Canons of Notre Dame-des-Doms in Avignon had been guarding jealously.[27] This kind of thing indicates, in fact, a certain undervaluing of art, a tendency to think of artists as objects to be used and exchanged. It fosters an image of the medieval artist as someone dedicated to humble service of faith and the community, someone very different from the Renaissance artist, who was boastfully convinced of his uniqueness.

The Scholastic theory of art supported this humble image, for its wholly objectivist conception of art ignored the personal imprint of the artist upon his work. As well as this, there was a pervasive tendency to look down on the 'mechanical' arts; as a result, architects and sculptors did not feel encouraged to seek personal fame. The work of figurative artists was carried out in the context of urban and architectural construction, and was part of a team effort, so that their only personal memento would be monograms carved upon the keystone. It is not unlike the situation nowadays where films are taken as more or less anonymous works by people who do not bother to read the credits. They remember plot and character, but are unconcerned with the makers.

Poets, however, were rather different, and won a full appreciation of their importance early on. The 'mechanical' arts have bequeathed

[27] See Victor Mortet, p. 305.

to us the names of only the most famous architects, but every poem has a definite author, who is aware of his own originality in style and in thought. There is abundant testimony to this, in Joseph the Scot, Theodulf of Orleans, Walafrid Strabo, Bernard Silvestris, and Geoffrey of Viterbo. From the eleventh century onwards, poets were quite aware that their work was a means of immortality. As it happens, it was at about this time that the term *ars* began to refer primarily to Logic and Grammar, and these began to supersede the study of *auctores*, or men of letters, which had still been a living discipline in the time of John of Salisbury. But writers reacted to this lessening of interest by insisting on their importance even more. Jean de Meun, for example, said that nobility of birth was as nothing to the nobility of the man of letters.

Thus, the illustrators were always monks, and master masons were artisans tied to their Guild, but the new generation of poets were always court poets, immersed in the life of the Aristocracy and honoured in the households where they lived. The poet did not work for God, nor for a community; he did not work at projects which would be completed by others after him; he did not try for the approval of the erudite. What he wanted was the glory of quick success and personal fame. The illustrators, even when like the brothers of Limbourg they worked for a princely household, remained anonymous. It was only when painters began to labour in workshops amidst everyday life, as happened in Italy from the thirteenth century onwards, that people began to gossip about them as individuals. They became the focus of an interest which individuated and divided them.[28]

All the same, the artists's personal pride was not entirely based upon the belief that his work was personal and original. For such a belief received no theoretical support from philosophy, despite the potential of the concept of *haecceitas*. It was at best a confused belief in the Middle Ages, and was not clarified until the Renaissance and Mannerism.

[28] On the condition and self-consciousness of the medieval artist see ET, II, pp. 406–20; E. R. Curtius, pp. 485–6; Arnold Hauser, I, pp. 244–52.

XI. Conclusion

1. MEDIEVAL aesthetics was filled with repetitions, regurgitations, and polemics of sometimes marginal import, yet it did have a certain overall direction. We must not forget that the Middle Ages, even in aesthetic theory, were a connecting link between the Classical period and the Renaissance. They have handed on to the modern era an artistic tradition modified by their own vision.

It began with a Pythagorean aesthetics of number, which was a reaction to the disorder and insecurity of the centuries following the fall of the Roman Empire, and moved on to the humanistic aesthetics of the Carolingian Renaissance, which was mindful of the value of art and the beauty of the Classical heritage. Then, with the emergence of a stable political order, there emerged also a systematic theological ordering of the universe; and once the crisis of the year 1000 was past, aesthetics became a philosophy of cosmic order. This was due to the influence of Eriugena, representative of a north-western culture already rich and mature even during the pre-Carolingian darkness. Then, while Europe was covering itself 'with a white mantle of churches', the Crusades stirred up the provincialism of the Medievals. The communal war effort gave them a new civic consciousness, and philosophy opened itself to the myth of Nature. People began to acquire a more detailed knowledge of natural objects, and as they did so beauty changed from being a property of the ideal order to being a property of concrete particulars. During the period between Origen, who insisted upon the physical ugliness of Christ, and the thirteenth-century theologians who made of Christ a dazzlingly beautiful prototype for artistic images, there was a maturing of the Christian ethos and the birth of a theology of the things of earth. The cathed-

rals expressed the world of the *Summae*, where everything was in its proper place: God and His angelic cohorts, the Annunciation and the last Judgment, death, human crafts, the devil himself, all subsumed in an order which measured and drew them within the circle of the substantial positivity of creation, and which was expressed in its form.

At the high point of its evolution, medieval civilisation attempted to capture the eternal essences of things, beauty as well as everything else, in precise definitions. The problem was, that it continued to have confidence in a humanism centred on the eternal realm, even though it had undergone a period of secularisation. So while philosophers were still preoccupied with essences, it appeared to the eyes of experience and of science that the essences had already changed. Systematic theory necessarily lagged behind the ferments and tensions of practical life. The Medievals perfected their image of political and theological order just when this order was being menaced on all sides – by the rise of nationalism, by vernacular languages, by a new kind of mysticism, by social pressures, by theoretical doubts. At a certain point Scholasticism – the ideology of a universal Catholic state of which the *Summae* were the constitution, the cathedrals the encyclopaedias, and the University of Paris the capital city – had to confront the poetry of secularism: with Petrarch expressing his contempt for the 'barbarians' of Paris; with the ferments of heresy; with the *devotio moderna*.

In the world of the cathedrals there had been no place for anguish and puzzlement; even Satan had his place. But now the world was shaken to its foundations. From the lamentations of Jean Gerson we pass on to Hieronymus Bosch: theological symbols become fearsome spectres, the devil a menace of desolation. Scholastic aesthetics was inadequate both for the northern medievalism now in decline, and for the new world that had been born in Italy – a world in which Platonism and magic gave new explanations of the invisible, and humane letters offered to mankind other types of guarantees and certainties.

2. Yet within its own limits Scholastic aesthetics did respond to the propensities and sensibilities of the world around it. Riegl has shown[1]

[1] A. Riegl, *Spätrömische Kunstindustrie* (Vienna, 1901).

in his study of the art of late Antiquity, that the aesthetic theories of a given period are an indication of its *Kunstwollen*: the formal characteristics of an art are reflected in the theoretical consciousness of its contemporaries. I have tried, in a limited way, to indicate where this occurred in medieval aesthetics.

However, we cannot help noticing that the various formulae employed in medieval aesthetics are so general, and so logically perfect in their context, that they could refer to everything or to nothing. Its philosophy of beauty appears cut off from its artistic practices as if by a sheet of glass. On the one hand there was a geometrically rational schema of what beauty ought to be, and on the other the unmediated life of art with its dialectic of forms and intentions. Still, we have seen that the very verbalism and idealism of medieval aesthetics expressed the dualistic mentality of the age, its continual tension between the theory of what ought to be the case and the contradictions of life. It was a dualism which did not invalidate the medieval integration of values, but constituted rather a paradoxical feature of this integration itself. It was an age which could make a public spectacle of the most extreme ferocity and wickedness, and yet which lived according to a code of piety, firm in its belief in God and sincere in its pursuit of a moral ideal which it contravened with great facility and candour. Nowadays we look back at them rather critically. We take note of the contradictory aspects of their culture; we are unable to reconcile, within a single orthodoxy, Héloise and the characters in Chaucer, Boccaccio and Gilles de Rais. But the Medievals tended to stress the points of convergence and unity, overcoming the contradictions by faith and hope. Their aesthetics, like all their thinking, expressed an optimum synthesis. They saw the world with the eyes of God.

An accurate reconstruction of medieval aesthetics is important for its own sake. In addition, its generality and rigour make it valuable reading even nowadays. Some of its features we cannot assimilate, but some of its formal categories can be the source of fresh insights. This has already happened in the case of a contemporary who battled à *les frontières de l'illimité et de l'avenir*: James Joyce.[2] Medieval aesthetics, together with the Greek tradition, can suggest the ideal of a

[2] See Umberto Eco, *The Aesthetics of Chaosmos—the Middle Ages of James Joyce* (Tulsa, 1982); Hugh Bredin, 'Applied Aquinas: James Joyce's Aesthetics', in *Éire-Ireland*, III (Spring, 1968), pp. 61–78.

new *kalokagathía*, and create a sense of the harmony of reason. This has already happened in such naturalistic philosophers as Dewey.[3] Medieval aesthetics can indicate a method of combining Classical and modern conceptions of art.[4] It can display unsuspected affinities with Oriental thought of the same period.[5] It can foster a conception of art as something constructive and technical, thus serving as an antidote to an Orphic one, typical of post-Romantic aesthetics. It can inspire critical methods committed to rigour and rationality.[6] Indeed, anyone at all who tries to interpret it sensitively can learn something: not because it is the expression of a civilisation better than any other, but because this is the value of any civilisation and any doctrine of the past, when we seek to discover its lessons for the present.

[3] John Dewey, *Art as Experience* (New York, 1934).
[4] A good example of this is Jacques Maritain, *Creative Intuition in Art and Poetry* (London, 1953).
[5] See Ananda Coomaraswamy, *The Transformation of Nature in Art*.
[6] Elements of Aristotelianism and of medieval Rhetoric appear in the 'Chicago School' of criticism. See R. S. Crane, ed., *Critics and Criticism* (Chicago, 1952).

Bibliography

This is a slightly amended version of Professor Eco's Bibliography. I have added or substituted English translations when available and where appropriate, and have occasionally cited a different or more recent edition. As the original text was published in 1959 I have thought it useful to append a supplementary bibliography of more recent works.

H.B.

TEXTUAL SOURCES

The textual sources of medieval aesthetics are, in a very broad sense, the same as those of medieval philosophy in general, although some poetic and scientific works are relevant documents as well. In this section, I have listed only the most important collections, where almost all of the texts which I have cited may be found.

Albertus Magnus, *De Pulchro et Bono*, in St. Thomas Aquinas, *Opera Omnia* (see below), vol. VII, pp.43-7.

Alexander of Hales, *Summa Theologica* (Florence, 1924, 1928, 1930, 1948).

Baumker, Clemens, *Witelo* (Münster, 1908).

Bonaventure, St., *Opera Omnia* (Florence, 1902).

Cennini, Cennino, *Il libro dell'arte*, edited by Daniel V. Thompson (New Haven, 1932); *The Craftsman's Handbook*, translated by Daniel V. Thompson (New Haven, 1933).

Conrad of Hirschau, *Dialogus Super Auctores*, edited by G. Schepss (Wurzburg, 1889).

De Coussemaker, E., *Scriptorum de Musica Medii Aevi*, 4 vols. (Hildesheim, 1963; 1st pub. Paris, 1864-7).

Faral, Edmond, *Les arts poétiques du XIIe et du XIIIe siècle* (Paris, 1924).

Gerbert, Martin, *De Cantu et Musica Sacra a Prima Ecclesiae Aetate usque ad Praesens Tempus* (St. Blasien, 1774).

————, *Scriptores Ecclesiastici de Musica Sacra Potissimum*, 3 vols. (Hildesheim, 1963; 1st pub. St. Blasien, 1784).

Halm, C., *Rhetores Latini Minores* (Leipzig, 1863).

Holt, Elizabeth G., *A Documentary History of Art*, 2 vols. (New York, 1957; 1st ed. Princeton, 1947), vol.I.

Migne, J.P., *Patrologiae Cursus Completus. Series Latina* (Paris, 1844-90).

Montano, Rocco, *L'estetica nel pensiero cristiano*, in *Grande Antologia Filosofica* (Milan 1954), vol.V, pp.151-310; texts in pp.207-310.

Mortet, Victor, *Recueil de textes relatifs à l'histoire de l'architecture, XIe-XIIe siècles* (Paris, 1911).

Mortet, Victor and Deschamps, Paul, *Recueil de textes relatifs à l'histoire de l'architecture, XIIe-XIIIe siècles* (Paris, 1929).

Pellizzari, A., *I trattati intorno alle arti figurative in Italia e nella penisola iberica dall'antichità classica al Rinascimento* (Naples, 1915), vol.I.

Pouillon, Henri, 'La Beauté, propriété trancendentale chez les scolastiques', *Archives d'histoire doctrinale et littéraire du Moyen Age*, XXI (1946), pp. 263-329.

Robert Grosseteste, *On Light*, translated by Clare C. Riedl (Milwaukee, 1942).

Suger, *De Rebus Administratione Sua Gestis*, and other writings, in Erwin Panofsy, *Abbot Suger on the Abbey Church of St.-Denis and its Art Treasures* (Princeton, 1946).

Theophilus, *De Diversis Artibus (Schedula Diversarum Artium)*, edited and translated by C.R. Dodwell (London, 1961).

Thomas Aquinas, St., *Opera Omnia*, edited by Roberto Busa, 7 vols. (Stuttgart, 1980).

Villard de Honnecourt, *Album de Villard de Honnecourt*, edited by J.B.A. Lassus and Alfred Darcel (Paris, 1968).

Vincent de Beauvais, *Speculum Majus* (Venice, 1494).

William Durandus, *Rationale Divinorum Officiorum* (Treviso, 1479); Book I translated in J.M. Neale and B. Webb, *The Symbolism of Churches and Church Ornaments* (Leeds, 1843).

Works by Boethius, Isidore of Seville, Cassiodorus, John Scottus Eriugena, Alcuin, Hugh and Richard of St. Victor, Alan of Lille, John of Salisbury, William of Conches, and others can be located in Migne's *Patrologia Latina*. The most important texts for thirteenth century aesthetics are in Pouillon. Montano's collection is very diverse in scope, and is an excellent introduction to a much larger body of philosophical literature on beauty. Moreover, it is preceded by one of the most rewarding studies of medieval aesthetics which has yet appeared in Italy. Unlike the present work, Montano examines extensively the poetics of Dante and the conjunction therein of numerous currents in medieval aesthetics.

GENERAL WORKS

Any history of aesthetics will give a general account of the medieval period. Some of these are quite unsatisfactory, due to an inadequate knowledge of the medieval literature or of medieval culture:

Biondolillo, F., *Breve storia del gusto e del pensiero estetico* (Messina, 1924), chapter 2.

Borgese, G.A., 'Sommario di storia della critica letteraria dal Medioevo ai nostri giorni', in *Poetica dell' unità* (Milan, 1952).

Bosanquet, B., *A History of Aesthetics* (London, 1904), chapter 6.

Croce, B., *Estetica* (Bari, 1902); *Aesthetic*, translated by Douglas Ainslie (London, 1909), Part II, chapter 2.

Gilbert, K., and Kuhn, H., *A History of Esthetics*, second edition (London, 1956), chapter 5.

Saintsbury, G., *A History of Criticism and Literary Taste in Europe*, 3 vols. (Edinburgh, 1900-4), vol. I, Book 3.

Zimmerman, R., *Geschichte der Aesthetik als Philosophische Wissenschaft* (Vienna, 1858).

By far the most stimulating of these is Saintsbury. The Idealism of Croce and Bosanquet prevents them from seeing the true character of medieval problems. Croce's well-known assessment of medieval aesthetics is valid only if one identifies aesthetics with a philosophy of lyrical intuition; it is a manner of doing historical research that leads to perplexity. Gilbert and Kuhn's treatment is fruitful and has moments of insight, but unfortunately they depend almost entirely upon secondary sources.

The following works are greatly superior, indeed fundamental.

Curtius, E.R., *European Literature and the Latin Middle Ages* (London, 1953).

De Bruyne, Edgar, *Études d'esthétique médiévale*, 3 vols. (Bruges, 1946).

———, *L'esthétique du Moyen Age* (Louvain, 1947); *The Esthetics of the Middle Ages*, translated by E.B. Hennessy (New York, 1969).

———, *Geschiedenis van de Aesthetica*, 5 vols. (Anvers, 1951-5).

De Wulf, M., *L'oeuvre d'art et la beauté* (Louvain, 1920); *Art and Beauty*, translated by M. Udell (St. Louis, 1950), Appendix.

Glunz, H.H., *Die Literarästhetik des Europäischen Mittelalters* (Bochum, 1937).

Menéndez Y Pelayo, M., *Historia de las ideas estéticas en Espana* (Madrid, 1883), chapters 3-5.

Müller, W., *Das Problem der Seelenschönheit im Mittelalter* (Berlin, 1926).

Panofsky, Erwin, *Idea: a Concept in Art Theory* (Columbia, 1968; 1st pub. 1924).

Schlosser Magnino, J., *Die Kunstliteratur* (Vienna, 1924); *La letteratura artistica*, translated by F. Rossi, 3rd edition (Florence, 1964).

——, *Die Kunst de Mittelalters* (Berlin, 1926).

For any serious work on the period, De Bruyne's *Études* is indispensable. It is a treasurehouse of original texts; indeed, this is all that its author intended it to be intitially. It is also an analytically precise study of individual aesthetic viewpoints, which at the same time places them profoundly in their context. The work is pervaded by a sensibility alert to aesthetic problems, always ready to suggest the respects in which medieval theories are of contemporary interest, though without forcing the issue. De Bruyne 1947 is a useful summary of *Études*, in which he orders the material thematically rather than by individuals or schools. It is not suitable for consultation purposes since it does not give bibliographical references to the texts (footnotes direct the reader to the corresponding references in *Études*). De Bruyne 1951-5 is unfortunately less than fully accessible for reasons of language. *Études* had ended with Duns Scotus; this work extends into the late Middle Ages, and deals with Chaucer, Cennini, Dionysius the Carthusian, etc.; and it extends back as far as the Patristic period.

Compared with De Bruyne, Glunz's inquiries are more limited. He is mainly interested in the poet's consciousness in regard to his own art. He traces the evolution of medieval literary taste, and locates the definitive appearance of an 'aesthetic' conception of poetry in the fourteenth century. In a review of Glunz, De Bruyne objected that it was dangerous to divide up historical periods in accordance with the evolution of aesthetic trends, because medieval aesthetics is always characterised by the simultaneous presence of its various trends. Still, if one should desire to investigate the problem of artistic self-consciousness, undoubtedly some such work as Glunz's would be called for.

Schlosser Magnino's works are first and foremost enormous and well-organised bibliographies. All the same, his treatment of the medieval period is full of useful comments on theories of art and comparisons with the aesthetics of the Classical tradition.

Curtius explores those elements of medieval Latin culture which were converging into a European literary culture: its focal points, its archetypes, its rhetorical strategies, and so on. Various chapters, and especially its numerous appendices, deal with problems of aesthetic theory. The particular interest of the latter is that they look at those conceptions which were to be developed further in subsequent centuries.

Menéndez Y Pelayo deals with texts and theories of Spanish, Arabic, and Judaic culture. Panofsky's *Idea* is a lively monograph on the history of the concept of an artistic 'idea'. It is rich and profound on the Renaissance and Mannerism, but less effective on the medieval period. In his Preface to the Italian translation (1952), Panofsky said that he considered the book to be superseded, one reason being that in 1924 he had not had access to works such as De Bruyne's. However, it remains a useful work and is full of insights.

WORKS ON MEDIEVAL CULTURE AND AESTHETIC SENSIBILITY

The works cited here do not deal directly with aesthetics, but are useful for an understanding of the medieval spirit. It is only in the light of these clarifications of its civilisation and culture that its philosophical treatises on the beautiful can be properly interpreted.

Chailley, J., *Histoire musicale du Moyen Age* (Paris, 1950).

Coulton, G.G., *Medieval Panorama* (Cambridge, 1938; 2nd edition New York, 1955).

Dvorak, M., *Idealismus und Naturalismus in der Gotischen Skulptur* (Munich, 1928); *Idealism and Naturalism in Gothic Art*, translated by Randolph J. Klawiter (Notre Dame, 1967).

Fichtenau, H., *Das karolingische Imperium* (Zurich, 1949); *The Carolingian Empire*, translated by Peter Munz (Oxford, 1957).

Focillon, H., *Art d'Occident* (Paris, 1938); *The Art of the West*, translated by Donald King, 2 vols. (London, 1963).

——, *L'an mil* (Paris, 1952).

Gilson, E., *L'esprit de la philosophie médiévale* (Paris, 1932); *The Spirit of Medieval Philosophy*, translated by A. Downs (New York, 1936).

——, *Les idées et les lettres* (Paris, 1932).

——, *Héloïse et Abélard* (Paris, 1938).

——, *La philosophie au Moyen Age* (Paris, 1944).

Gregory, Tullio, *Anima Mundi* (Florence, 1955).

Guzzo, A., *Studi d'arte religiosa* (Milan, 1932).

Haskins, C.H., *The Renaissance of the Twelfth Century* (Cambridge, Mass., 1927).

Hauser, Arnold, *The Social History of Art*, 2 vols. (London, 1951).

Huizinga, J., *The Waning of the Middle Ages* (Harmondsworth, 1965).

Krestowsky, L., *La laideur dans l'art à travers les âges* (Paris, 1947).

Langlois, C., *La connaissance de la nature et du monde, d'après les écrits français à l'usage des laïcs* (Paris, 1927).

Malraux, A., *Les voix du silence* (Paris, 1951); *The Voices of Silence*, translated by Stuart Gilbert (London, 1954).

Montano, R., 'Introduzione ad un'estetica del Medioevo', *Delta*, V (1953), pp.59-67.

Mumford, L., *The Condition of Man* (New York, 1944), chapters 3 and 4.

Nulli, S.A., *Erasmo e il Rinascimento* (Turin, 1955).

Paré, G., *Les idées et les lettres au XIIIe siècle* (Paris and Montreal, 1947).

Paré, G., Brunet, A., and Tremblay, P., *La Renaissance du XIIe siècle* (Ottawa, 1933).

Taylor, H.O., *The Medieval Mind*, 2 vols. (London, 1911).

Valentini, R. and Zucchetti, G., *Codice topografico della città di Roma*, 4 vols. (Rome, 1940, 1954), vol.III (which includes a critical edition of *Mirabilia Urbis Romae*).

Weymann, U., *Die seusesche Mystik und ihre Wirkung auf die bildende Kunst* (Berlin, 1938).

Worringer, W., *Formproblem der Gotik* (Munich, 1930); *Form in Gothic*, edited by Herbert Read (London, 1957).

Works such as those of Gilson are essential for an understanding of the medieval sensibility. His book on Héloïse and Abélard is an excellent introduction to the problem of defining medieval humanism. Erudite, filled with Latin quotations, and with all the life and charm of a romance, it enables the reader to see in medieval man an open humanity, in the modern sense of that term—the humanity which is a fundamental presupposition of aesthetic interests as they are nowadays conceived. By way of contrast I have cited Nulli's book about Erasmus. This examination of Renaissance man contrasts him sharply with medieval man. But it is the medieval man of convention. Nulli's work is a recent expression of a kind of anti-medieval viewpoint which had already been severely castigated by Gilson and others. Nulli wants to resist just this reinstatement of medieval humanism but he does so with an acrimony which mars the genuine distinctions between the medieval and Renaissance spirits which he does make.

Hauser finds quite a different kind of richness and ferment in the medieval period. His perspective is that of a liberal Marxist, and he provides an excellent introduction to the relations among artistic phenomena, artistic theories, and the socio-economic 'base'. His work is written in a popular style, but is based on solid erudition and it contains echoes of other, more profound studies, such as that of Dvorak (Hauser was in fact a pupil of Dvorak).

Taylor is very clear and explanatory, filled with quotations, and deals with various aspects of medieval artistic culture: the philosophers, encyclopedists, Mystics, troubadours.

Focillon's *The Art of the West* is an impassioned study of medieval figurative art, as an expression of the total culture of the period and as an original and exalted creation of the spirit of the West. His *L'an mil* gives a clear account of the rise of a new humanistic spirit in our own millenium. Fichtenau describes the humanism already present, albeit with its own distinctive character, in Carolingian civilisation. Mumford gives a captivating account, unprejudiced and shrewd, of the development of the medieval sensibility.

The number of occasions on which I have quoted from Huizinga shows how fruitful I have found him to be. His field of study is limited—Burgundian civilisation in the fourteenth and fifteenth centuries. His conception of history, combined with his conception of culture as 'play' and as stylisation, means that his interpretation is incomplete, yet his work is of the utmost interest and includes abundant documentation. The medieval period in its decline reveals grandeur and misery in its ideas and ways of life which are very relevant to an understanding of the previous centuries, for they reveal their possibilities and limits.

Mirabilia Urbis Romae documents the artistico-archaeological sensibility of the medievals. Krestowsky describes a consciousness of the ugly which seems partially opposed to the pure and optimistic philosophy of beauty although thinkers who attempted to give formal justifications of the ugly, like Bonaventure, attempted to validate such phenomena. Weymann, in considering the influence of mysticism upon late medieval art, stresses its more 'expressionistic' moments.

Malraux is rather unsystematic and not suited for consultation purposes. But he makes interesting comments on Gothic art, and upon the psychology of medieval aesthetic experience.

Gregory's work on the twelfth century cultural renaissance pays particular attention to the new philosophical concept of nature which derived from the theology and the poetry of the period. Chailley deals with the development of an aesthetic sensibility in connection with musical theory and practice.

ON THE AESTHETICS OF MUSICAL ORDER, AND OF PROPORTION

In this section I list some works that deal with the mathematical and musical aspects of medieval art, and the corresponding aesthetic theories.

Abert, J.J., *Die Musikanschauung des Mittelalters und ihre Grundlagen* (Leipzig, 1905).

Allers, R., 'Microcosmus from Anaximandros to Paracelsus', *Traditio*, II(1944), pp.319-407.

Baltrusaitis, J., 'Le style cosmographique au Moyen Age', *IIe Congrès d'esthétique et de science de l'art* (Paris, 1937), vol.II.

Combarieu, J., *Histoire de la musique* (Paris, 1910), vol.I.

Ghyka, M., *Le Nombre d'Or: rites et rythmes pythagoriciens dans le développement de la civilisation occidentale*, 2 vols. (Paris, 1931).

Irtenkauf, W., 'Der *Computus ecclesiasticus* in der Einstimmigkeit des Mittelalters', *Archiv für Musikwissenschaft*, XIV(1957), pp.1-15.

Panofsky, Erwin, *Gothic Architecture and Scholasticism* (London, 1957).

————, 'The History of the Theory of Human Proportions as a Reflection of the History of Styles', in *Meaning in the Visual Arts* (Harmondsworth, 1970).

Réau, Louis, 'L'influence de la forme sur l'inconographie de l'art médiévale', in *Formes de l'art, formes de l'esprit*, by various authors (Paris, 1951).

Silva-Tarouca, A., *Thomas heute* (Vienna, 1947).

Simson, O. von, 'Wirkungen des christlichen Platonismus auf die Entstehung der Gotik', in *Humanismus, Mystik und Kunst in der Welt des Mittelalters*, edited by J. Koch (Leiden, 1953).

————, *The Gothic Cathedral* (New York, 1956).

In studies of medieval musical theory it is normal to give particular attention to the concept of proportion. Panofsky and Simson are unusually interesting, however, in that both look upon medieval figurative art as a source and an embodiment of a theory of proportion. Panofsky analyses the various forms of various concepts of proportion in Byzantine, Medieval Latin, Egyptian, Greek, and Renaissance art, in practice and in precept alike. He defines the medieval idea of proportion rather narrowly, perhaps, specially in the essay in *Meaning in the Visual Arts*; in effect he deduces his definition from concrete instances, without referring to the philosophical concept of proportion which connects it with metaphysical beauty.

Simson examines the origins of Gothic architecture in relation to the Scholastic concept of order. He identifies those cases where religious experience and a particular vision of the world exerted an influence upon the forms and techniques of construction. Chartres cathedral, for example, reflects the Platonism of the School of Chartres. In an appendix to *The Gothic Cathedral*, E. Levi studies the proportions used for the spires of Chartres, with frequent reference to Vitruvius and to theories of music. The aesthetic concept of order permeated almost all of medieval metaphysics; Silva-Tarouca, though he does not refer explicitly to the problem of the beautiful, examines the role of the concept of order in Thomist metaphysics.

SYMBOL AND ALLEGORY

Many of the works already cited, De Bruyne and Huizinga for instance, contain important discussions of medieval symbol and allegory. Here I cite more specialised studies.

Alverny, M.M., 'Le cosmos symbolique du XIIe siècle', *Archives*, XX(1953), pp.31-41.

Baldwin Smith, E., *Architectural Symbolism of Imperial Rome and the Middle Ages* (Princeton, 1956).

Baltrušaitis, J., *Le Moyen Age fantastique* (Paris, 1955).

Comparetti, D., *Vergil in the Middle Ages* (London, New York, 1895).

Dunbar, H.F., *Symbolism in Medieval Thought* (New Haven, 1929).

Huysmans, J.K., *La Cathédrale* (Paris, 1937).

Mâle, E., *L'art religieux du XIIe siècle en France*, 4th edition (Paris, 1941): *Religious Art in France*, translated by Marthiel Matthews (Princeton, 1978).

Réau, L ., *Iconographie de l'art chrétien*, 3 vols. (Paris, 1955-9), Introduction.

Medieval allegorical writings can be read in ways for which they were not intended. This can give rise to a hermeneutics of architecture which, for all the significance it places upon this important aspect of the medieval mentality, loses its way in a web of speculative meanings. Baldwin Smith looks upon medieval architecture as a mass of symbolico-cosmic associations, both celestial and imperial, where arches and cupolas come to signify political ascendancies. Thus, Carolingian architecture tended to assert the superiority of State over Church; and the spires of the vestibule of Chartres suggest the pro-imperialist politics of the Abbacy. A strict and useful sociological interpretation of art-forms here topples over into something cryptic and facile. The same applies in the extreme to the disordered and romanticist work of Huysmans. He is interesting none the less, for he uses the original texts to reconstruct the encyclopaedist spirit of the Medievals, but in terms of *fin de siècle* decadence.

Mâle's studies of the figurative arts are wholly different in their importance, balance, and value. They are indispensable for an understanding of the mechanics and the cultural psychology of the allegoristic conception of medieval figurative artifacts. Mâle has often been accused of being too strictly theological in his interpretation of medieval art. However, it can hardly be denied that every critical viewpoint has its own particular emphasis and exclusions. Mâle tends to look upon cathedrals as educative artifacts first and foremost, as a form of didactic communication. In this sense he arrives at a full understanding of cathedrals only after a 'hecatomb of learning': biblical, theological, scientific. Still, it is clear that without these socio-cultural assumptions any understanding of the medieval cathedral could be only a partial one. An aesthetics of pure visibility could not explain its original intentions nor its true character.

Another important and well documented study is that of Réau; indeed, it is the most recent and up to date work on this topic. He provides significant treatments of various symbolisms: universal, animal, mineral, vegetable, and human. Baltrušaitis, an indefatigable collector of the unusual, concerns himself with the rare and the curious. Imageries which other writers describe as complex creations of medieval allegorism are attributed by him to exotic influences. Thus, Huizinga looks upon the *danse macabre* as one of the most typical and original manifestations of the late medieval sensibility. Baltrušaitis claims instead that it has a Tibetan source.

THEORIES AND RULES OF ART

Here I list works dealing with theories of art, poetics, rhetoric, and medieval manuals of technique. Many important discussions of these matters are to be found in books that I have already mentioned, such as Schlosser Magnino, Glunz, and Curtius. It should be borne in mind that the analysis of medieval conceptions of artistic technicalities goes beyond the scope of the present study, whose subject matter is philosophical theories, not poetics.

Baldwin Smith, E., *Medieval Rhetoric and Poetic* (New York, 1928).

Charland, T.M., *Artes Praedicandi* (Paris and Ottawa, 1936).

Faral, E., 'Sidioinc Apollinaire et la technique littéraire du Moyen Age', in *Miscellanea Mercati* (Vatican, 1946).

Franceschini, E., 'La Poetica di Aristotele nel secolo XIII', *Atti dell'Istituto Veneto*, 1934-5.

————, 'Ricerche e studi su Aristotele nel medioevo latino', in *Aristotele nella critica e negli studi contemporanei*, by various authors (Milan, 1956).

Garin, Eugenio, *Medioevo e Rinascimento* (Bari, 1961).

Loumyer, G., *Les traditions techniques de la peinture médiévale* (Paris, 1920).

Maggini, F., *La retorica italiana di B. Latini* (Florence, 1913).

McKeon, R., 'Rhetoric in the Middle Ages', and 'Poetry and Philosophy in the Twelfth Century', in *Critics and Criticism*, edited by R.S. Crane (Chicago, 1952).

Robert, S., 'Rhetoric and Dialectic: According to the First Commentary on the *Rhetoric* of Aristotle', *The New Scholasticism*, **XXXI**(1957), pp.484-98.

Ruggieri, R.M., 'Estetica letteraria del Medioevo', *Cultura Neolatina*, I(1941), pp.192-212.

Schuhl, P.M., 'Beaux-Arts et Métiers', *IIe Congrès Internationale d'esthétique et de science de l'art* (Paris, 1937), vol. I.

Tatarkiewicz, W., 'Art et poésie dans le dualisme esthétique des anciens', *IIe Congrès Internationale d'esthétique et de science de l'art* (Paris, 193)), vol.II.

Garin is particularly interesting. He discusses the problem of the poet's self-awareness, and gives a useful treatment of Ockham, and of the dissolution of Scholasticism. McKeon's essays are dense and well documented. Franceschini investigates the history of Aristotelian poetics in the Middle Ages. He establishes precise criteria for determining which medieval thinkers availed of Aristotelian theories of art. Medieval theory of art had this peculiarity, that it was Aristotelian in its general philosophical character, but was unaware of Aristotle's actual aesthetics. Except for some comments of Averroes, it knew nothing of that celebrated definition of poetry which could have suggested to them a distinction between art in general and the fine arts, or, at least, the poetic art.

Tatarkiewicz's essay is short but valuable.

STUDIES OF PARTICULAR AUTHORS AND PERIODS

This is only a selection of works about particular authors. In the case of Aquinas's aesthetics, the bibliography is vast, and most of it deals with problems that are larger in scope than medieval aesthetics. However, I have given the most exhaustive list that I can.

Badt, K. 'Der Gott und der Kunstler', *Philosophisches Jahrbuch*, LXIV(1956), pp.372-92.

Baron, R., 'L'esthétique de Hugues de St. Victor', *Les Études Philosophiques*, III(1957), pp.434-7.

Bizzarri, R., 'Abbozzo di una estetica secondo i principi della scolastica', *Rivista Rosminiana*, XXIX(1935), pp.183-96.

―――, 'San Tommaso e l'arte, *Rivista di Filosofia Neoscolastica*, XXVI(1934), pp.88-98.

Callahan, L., *A Theory of Aesthetics According to the Principles of St. Thomas of Aquino* (Washington, 1927).

Chiocchetti, E., *San Tommaso* (Milan, 1925), chapter 5.

Coomaraswamy, A.K., 'Medieval Aesthetics: Dionysius the Pseudo-Areopagite and Ulrich Engelberti of Strasbourg', *Art Bulletin*, XVII(1935), pp.31-47

―――, 'Meister Eckhart's View of Art', in *The Transformation of Nature in Art* (Harvard, 1934).

―――, 'St. Thomas Aquinas on Dionysius and a Note on the Relation of Beauty to Truth', *Art Bulletin*, XX(1938), pp.66-77.

De Munnynck, M., 'L'esthétique de St. Thomas', in *S. Tommaso d'Aquino*, by various authors (Milan, 1923).

Du Wulf, M., *Études historiques sur l'esthétique de St. Thomas d'Aquin* (Louvain, 1896).

Dyroff, A., 'Zur allgemeinen Kunstlehre des Hl. Thomas', in *Festgabe zum 70 Geburtstag Clemens Baumker* (Münster, 1923).

Eco, Umberto, *Il problema estetico in Tommaso d'Aquino*, 2nd edition (Milan, 1970).

Gilby, T., *Poetic Experience: an Introduction to Thomist Aesthetics* (New York, 1934).

Groenewoud, A. van, 'De schoonheidsleer van der H. Thomas van Aquino', *Bijdragen van Phil. en Theol. Faculteites der Neederlandische Jezuiten* (1938), pp.273-311.

Improta, G., *Contributo dell'Angelico Dottore San Tommaso alla dottrina ed all'evoluzione del bello e dell'arte estetica* (Naples, 1933).

Koch, J., 'Zur Aesthetik des Thomas von Aquin', *Zeitschrift für Aesthetik*, XXV(1931), pp.266-71.

Lingueglia, P., 'Le basi e le leggi dell'estetica secondo San Tommaso', in *Pagine d'arte e di letteratura* (Turin, 1915).

Lutz, E., 'Die Aesthetik Bonaventuras', in *Festgabe zum 60 Geburtstag Clemens Baumker* (Münster, 1913).

Marchese, V., *Delle benemerenze di S. Tommaso verso le belle arti* (Genoa, 1874).

Mazzantini, C., *Linee fondamentali di un'estetica tomista* (Rome, 1930).

Melchiorre, V., 'Il bello come relazionalità dell'essere in S. Tommaso', in *Arte ed Esistenza* (Florence, 1956), pp.215-30.

Merlo, G.M., 'Il misticismo estetico di S. Tommaso', in *Atti dell'Accademia delle Scienze di Torino*, 1939-40.

Minuto, T., 'Preludi di una storia del bello in Ugo di San Vittore', *Aevum*, XXVI(1952), pp. 289-308.
Montagne, A., 'L'esthétique de St. Thomas', *Bulletin de l'Institut Catholique de Toulouse*, IIe serie, VI, 1894.
Nemetz, A.A., 'Art in St. Thomas', *The New Scholasticism*, XXV(1951), pp. 282-9.
Olgiati, F., 'San Tommaso e l'autonomia dell'arte', *Rivista di Filosofia Neoscolastica*, XXV(1933), pp. 450-6.
————, 'La *simplex apprehensio* e l'intuizione artistica', ibid., XXV(1933), pp.516-29.
————, 'San Tommaso e l'arte', ibid., XXVI(1934), pp.90-8.
————, 'L'arte e la tecnica nella filosofia di San Tommaso', ibid., XXVI(1934), pp.156-65.
———— , 'L'arte, l'universale e il giudizio', ibid., XXVII(1935), pp.290-300.
Pancotti, V., *San Tommaso e l'arte* (Turin, 1924).
Philippe, M.D., 'Situation de la philosophie de l'art dans la philosophie aristotélico-thomiste', *Studia Philosophica*, XIII(1953), pp.99-112.
Raynaud De Lage, G., *Alain de Lille, poéte du XIIe siècle* (Paris and Montreal, 1951).
Rodriguez, M.T., 'Aspectos da estética carolingia', *Revista Portuguesa de Filosofia*, XIII(1957), pp.158-73.
Sella, N., *Estetica musicale in San Tommaso* (Turin, 1930).
Spargo, E.J., *The Category of the Aesthetic in the Philosophy of St. Bonaventure* (New York, 1953).
Taparelli d'Azeglio, L., 'Delle ragioni del bello secondo la dottina di San Tommaso d'Aquino', 19 articles in *Civiltà Cattolica*, IV(1859-60).
Tea, E., 'Witelo, prospettico del secolo XIII', *L'Arte*, XXX(1927), pp.3-30.
Thiéry, A., *Les Beaux-Arts et la philosophie d'Aristote et St. Thomas* (Louvain, 1886).
Valensise, P., *Dell'estetica secondo i principi dell'Angelico Dottore*, (Rome, 1903).
Vallet, P., *L'idée du Beau dans la philosophie de St. Thomas d'Aquin* (Louvain, 1887).
Valverde, J.M., 'Introducción a la polémica aristotelico-tomista sobre la trascendentalidad metafisica de la bellezza', *Revista de Ideas Estéticas*, LII(1955), pp.305-17.

FREE INTERPRETATIONS OF MEDIEVAL AESTHETICS

In this section I include works whose intent is theoretical rather than historical, written for the most part in a context of neo-Thomism, or Catholicism at any rate. They tackle various issues in the light of medieval theories of art, and are influenced by Aquinas in particular. They are not, therefore, instruments of ordinary historical research. All the same, they can contribute to such research in two ways: first, as individuations and annotations upon medieval aesthetic theories; and second, in demonstrating which features of these theories can assume a contemporary significance. It is necessary, of course, to distinguish carefully between straightforward exegesis and independent developments.

Adler, M., *Art and Prudence* (New York, 1937).
Balthasar, N., 'Art, esthétique, beauté, *Revue Néoscolastique*, XXXIV(1933), pp.70-116.
Ceriani, G., 'La gnoseologia e l'intuizione artistica', *Rivista di Filosofia Neoscolastica*, XXVI(1934), pp.285-300.
Del Gaizo, V., 'Spunti tomistici per un'estetica moderna', *Humanitas*, II(1947), pp.373-86.
De Wulf, M., *L'Oeuvre d'art et la beauté* (Louvain, 1920); *Art and Beauty*, translated by M. Udell (St. Louis, 1950).
Duffy, J., *A Philosophy of Poetry Based on Thomistic Principles* (Washington, 1945).
Febrer, M., 'Metafisica de la belleza', *Revista de filosofia*, VII(1948), pp.91-134.
Marc, A., 'La Méthode d'opposition en ontologie thomiste', *Revue Néoscolastique*, XXXIII(1931), pp.149-69.
————, 'Metaphysique du Beau', *Revue Thomiste*, LI(1951), pp.112-133.
Maritain, J., *Art and Scholasticism* (London, 1930).
————, 'Signe et symbol', *Revue Thomiste*, XLIV(1938), pp.299-310; 'Sign and Symbol', *Journal of the Warburg Institute*, I(1937), pp.1-11.
————, 'De la connaissance poétique, *Revue Thomiste*, XLIV(1938), pp.87-98.
————, *Creative Intuition in Art and Poetry* (London, 1953).
Mercier, D., *Métaphysique générale ou ontologie* (Louvain, 1910), Part IV, chapter 4.

Plé, R., 'Ontologie de la forme', *Revue de Philosophie*, XXXVI(1936), pp.329-42.
Simonsen, V.L., *L'Esthétique de J. Maritain* (Copenhagen and Paris, 1957).
Trias, M., 'Nota sobre la belleza como trascendental', *Actas del Io Congreso Nacional de Filosofia* (Mendoza, 1949), vol. III.
Vanni-Rovighi, S., *Elementi di filosofia* (Milan, 1948), vol. II, chapter 5.
Wencelius, L., *La Philosophie de l'art chez les néoscolastiques de langue française* (Paris, 1932).

Maritain's *Art and Scholasticism* has the merit of revealing to a non-specialised public the possibility of an aesthetics expressed in terms of medieval philosophy, irrespective of whether the achievement is acceptable or not. It has been unexpectedly successful in circles far removed from the influence of Catholicism, and often quite indifferent to medieval culture. One such place is the United States, where some have found the Thomistic categories to fulfil the requirement of an Aristotelian rigour. Maritain has, on the one hand, employed medieval aesthetics to validate the works of Cocteau, Satie, Severini and Picasso; and on the other hand, he has investigated problems such as the transcendence of beauty and the nature of the aesthetic *visio*. Definitions such as 'Beauty is the splendour of the transcendentals when reunited' are rapidly becoming accepted explanatory formulae. Expressions such as *pulchrum est id quod placet* are accepted as authentic Thomistic formulae by people who do not care, or perhaps are not aware, that this is a definition devised by Maritain himself.

What Aquinas actually wrote was *pulchra dicuntur quae visa placent*. The difference is considerable. Maritain's proposition is a dogmatic attempt to define once and for all the ontological character of beauty. Aquinas's is more like a sociological finding. It means, 'Things which give pleasure when they are perceived are called beautiful', and this is to introduce the problem, not solve it.

This kind of thing illustrates the dangers which attend this type of work. A laudable commitment to the problems of the writer's own period leads to the substitution of his own thinking for that of someone else; speculative philosophy becomes mixed up with the historiography of medieval thought. Thus the interpretation of *visio* as an intellectual intuition of the sensible, an interpretation connected with the theory that artistic intuition is a *schéma dynamique*, leads insensibly to a conflation of Thomism with Bergsonism. Only the skill and ardour of Maritain's presentation can make this seem, at first sight, acceptable and it is only in his more recent *Creative Intuition in Art and Poetry* that Maritain gets rid of this ambiguity. Here we find a distinctive aesthetics in which Thomistic influences become a lesson from history which is assimilated freely. However, it is to Maritain that we owe the reinstatement of medieval aesthetics as a living force in contemporary thought, and this is no small debt. Simonsen's little book on Maritain is incomplete because it does not take account of his most recent work.

De Wulf is intelligent and balanced. Mercier's rethinking of the issues is still valid and filled with stimulating ideas. Vanni-Rovighi is clear and well documented.

Marc's essays upon the metaphysics of the beautiful, and Plé's upon the ontology of artistic form, are illuminating.

Wencelius's very accurate study has an unusual perspective, that of a Protestant historian considering his Catholic contemporaries.

These notes upon the free exploitation of medieval themes would not be complete without some reference to the aesthetic which can be extracted from various passages in Joyce's *A Portrait of the Artist as a Young Man* and *Stephen Hero*. Here the Thomistic categories are revitalised in a moral and ideological climate that is entirely heterodox. They are interpreted with considerable penetration, and transferred to a quite different culture and sensibility. In this connection I would mention my own *Le poetiche di Joyce* (Milan, 1966 now in English as *The Aesthetics of Chaosmos*, Tulsa Monograph Series 18, 1982), Virgilio Guidi, *Il primo Joyce* (Rome, 1954), and William T. Noon, *Joyce and Aquinas* (New Haven, 1957).

SUPPLEMENTARY BIBLIOGRAPHY OF RECENT WORKS

Assunto, R., *La critica d'arte nel pensiero medievale* (Milan, 1961).
———, *Die Theorie des Schönen im Mittelalter* (Cologne, 1963).
———, *Impostesi e postille sull'estetica medioevale* (Milan, 1975).

Barrett, C., 'The Aesthetics of St. Thomas Re-examined', *Philosophical Studies*, XII(1963), pp.107-24.

——, 'Medieval Art Criticism', *The British Journal of Aesthetics*, V(1965), pp.25-36.

Beardsley, M.C., *Aesthetics from Classical Greece to the Present* (New York, 1966), chapter 5.

Boglioni, P. (ed.), *La culture populaire au moyen âge* (Montreal and Paris, 1979).

Bundy, M.W., *The Theory of Imagination in Classical and Medieval Thought* (Folcraft, Pa., 1970; 1st published Indiana U.P., 1927).

Cataudella, Q., *Estetica cristiana*, in *Momenti e problemi di storia dell'estetica*, by various authors, 4 vols. (Milan, 1959, 1961), vol.I.

Chydenius, D., 'La théorie du symbolisme médiévale', *Poétique*, XXIII(1975), pp.322-41.

Copleston, F.C., *A History of Philosophy*, 7 vols. (London, 1946-63), vol.II, *Medieval Philosophy*.

Dales, R.C., *The Intellectual Life of Western Europe in the Middle Ages* (Washington, 1980).

Eco, Umberto, 'Storiografia medievale ed estetica teorica (Appunti metodologici su Jacques Maritain)', *Filosofia*, XII(1961), pp.505-22.

——, *Symbol*, in *Semiotics and the Philosopy of Language* (Bloomington, Indiana, U.P., 1984).

——, 'At the Roots of the Modern Concept of Symbol', *Social Research* 52,2 (1985), pp.383-402.

——, *L'Epistola XIII, l'allegorismo medievale, il simbolismo moderno*, in *Sugli Specchi* (Milan, 1985).

Flasch, K., 'Ars imitatur naturam. Platonischer Naturbegriff und mittelalterliche Philosophische der Kunst', in *Parusia* (Frankfurt, 1965).

Grabar, A., *Christian Iconography* (London, 1969).

Jeauneau, E., *La philosophie médiévale*, 2nd edition (Paris, 1967).

Kovach, F.J. *Die Aesthetik des Thomas von Aquin* (Berlin, 1961).

——, 'The Transcendentality of Beauty in Thomas Aquinas', in *Die Metaphysik im Mitterlalter* (*Miscellanea Mediaevalia*, II), edited by P. Wilpert (Berlin, 1963), pp.386-92.

Lindberg, D.C., *Theories of Vision from Al Kindi to Kepler* (Chicago, 1976).

Miller, Joseph M., Prosser, M.H., Benson, T.W. (eds.), *Readings in Medieval Rhetoric* (Bloomington, Ind. and London, 1973).

Murphy, J.J. (ed), *Three Medieval Rhetorical Arts* (Berkeley, Los Angeles, London, 1971).

——, *Rhetoric in the Middle Ages* (Berkeley, Los Angeles, London, 1974).

——, (ed.), *Medieval Eloquence: Studies in the Theory and Practice of Medieval Rhetoric* (Berkeley, Los Angeles, London, 1978).

Paul, J., *Histoire intellectuelle de l'occident médiéval* (Paris, 1973).

Pearsall, D. and Salter, E., *Landscapes and Seasons of the Medieval World* (London, 1973).

Perpeet, W., *Ästhetik im Mittelalter* (Freiburg, 1977).

Squarotti, G.B., *Le Poetiche del trecento in Italia*, in *Momenti e problemi di storia dell'estetica*, by various authors, 4 vols. (Milan, 1959, 1961), vol.I.

Tatarkiewicz, W., *History of Aesthetics*, 3 vols. (The Hague, 1970, 1974), vol.II.

Viscardi, A., *Idee estetiche e letteratura militante nel Medioevo*, in *Momenti e problemi di storia dell'estetica* by various authors, 4 vols. (Milan, 1959, 1961), vol.I.

Index